IMAGES OF ENGLAND

CHESHIRE LIFE

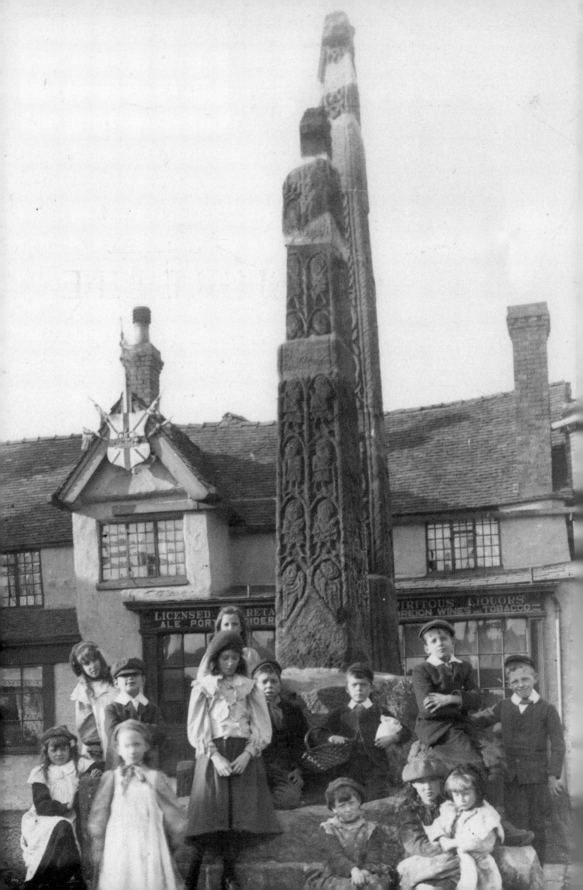

IMAGES OF ENGLAND

CHESHIRE LIFE

MIKE EDDISON AND JOHN HOPKINS

TEMPUS

Frontispiece: Cheshire old and young – children surround one of the county's oldest monuments, the ninth-century Anglo-Saxon crosses in Sandbach.

First published 2007

Tempus Publishing
Cirencester Road, Chalford,
Stroud, Gloucestershire, GL6 8PE
www.tempus-publishing.com

Tempus Publishing is an imprint of NPI Media Group

British Library Cataloguing in Publication Data.
A catalogue record for this book is available from the British Library.

ISBN 978 0 7524 4364 5

Typesetting and origination by NPI Media Group
Printed in Great Britain

Contents

Acknowledgements

We would like to thank the County Archivist for permission to use items held at the Cheshire Record Office (Cheshire and Chester Archives and Local Studies Service, Cheshire County Council) and for allowing us to include several photographs previously published in the *Archives and Local Studies Newsletter*. We are grateful to the many organisations and individuals who have deposited their archives over the years and thus made them available to a wider public.

Thanks also to the following, who have either allowed us to use their images or provided us with information: the Ordnance Survey; Tate Britain; the Salt Museum (Cheshire County Council); Warrington Library (Warrington Borough Council); Widnes Library (Halton Borough Council); the Cholmondeley Estate; Len Haywood; Colin Lynch and Martin Welch.

Introduction

Many thousands of words have been written on the history of Cheshire. The object of study, the county itself, like the giant Winwick oak, has been repeatedly lopped, in a regular round of 'reorganisation'. Major population centres like Birkenhead, Stockport and Runcorn have been excised. Warrington has come and gone from beneath the Cheshire canopy. For our purposes, we have not limited *Cheshire Life* to the surviving trunk that is the current county but have felt free to include anywhere that once lay within a 'Cheshire' boundary. Indeed, we have gone 'beyond the pale' in one or two instances, such as the two curious objects from the Cheshire Archives – the lady's riding glove from the West Country and the lock of hair from Windsor Castle – included, as Mobberley's mountaineering pioneer, George Mallory, might have put it, 'because it's there'.

This is not a 'history' of Cheshire in the traditional sense. Anyone wishing to research into the history of the county – or its geology and topography, for that matter – should start by going to the Cheshire and Chester Archives and Local Studies website, www.cheshire.gov.uk/recoff/home.htm, where there are catalogues listing many thousands of books, pamphlets, maps, and documents relating to Cheshire. All the main published histories of the county can be found there. This is, rather, a selection of images – arranged in broad subject groups – drawn predominantly from the archive and photographic collections at the Cheshire Record Office. It came about after the publishers saw the Record Office's online images at www.picturecheshire.co.uk and wondered if they could form the basis for a book. We felt that this might be possible, particularly if the photographs were combined with documents and other sources, and eventually came up with a set of images. They are the tip of the iceberg. Many classes of document and types of photograph are not represented, but we hope that the ones that have been chosen will be of interest.

Some of Cheshire's archives are particularly rich in photographs, such as the Basil Jeuda Collection of railway photographs and the Foden Collection. Others contain just a single album or a few separate images – such as the little Hanmer album featuring early photographs of a school in Wincham and the album of cuttings and photographs of the young men of the New Brighton Wesleyan Boating Club. All contribute in some small way to our visual heritage.

Some of our content will be little different when viewed today – White Nancy; the Sandbach Crosses; the churches at Barthomley and Barrow; and we still endorse those much photographed groups – the school class, the football team and the wedding party.

Other photographs reveal a displaced age – children that have time to 'stand and stare' like those in our Mobberley and Antrobus images; engineering marvels that once dominated their landscape – the Runcorn-Widnes Transporter bridge and the Tower at New Brighton; great waterways that survive but are no longer the vital arteries for trade that they once were, like the Manchester Ship Canal and the River Weaver; the rough justice handed out to the Cheshire witches; medicine when herbal cures were the popular option; huge public gatherings that once filled our town centres and, more recently, a 1923 'works outing' that was 'limited' to 2,000 people. With widespread automation and wholesale changes in forms of employment and working patterns, few of Cheshire's employers today are of a size to contemplate such an excursion – and even if they did, the obligatory 'risk assessment' would probably rule it out.

People form the main substance of the book – people at work, people at play – as children, as churchmen, as criminals, as soldiers. Thomas Allen, the Macclesfield JP, rails at the petty misdemeanours rife in his patch. As you read his notebook, you have to remind yourself that he is recording the 1820s and not the 1620s as he sentences William Wardle to be 'set in the stocks' for drunkenness, numerous vagrants to be 'ordered out of town', John Hassall to be 'confined and whipt' for being idle and disorderly and Thomas Illingworth to be committed as 'an incorrigible rogue'. Farmer Thomas Millan took the plunge when poor conditions at home and favourable reports from friends in America led him to sell up and take his family to Iowa in 1855. His diary records the harsh weather conditions that drove them back to Cheshire in 1857. He died just a few years later, in 1861, aged forty-two. There is little personal information about his own family in his diary, but it abounds with detail about other families in the Bunbury area: who is getting married, who has just died etc; market prices for farm produce; local crime; prevailing weather conditions; and a steady stream of rumour and superstition – including the following report on Egypt: 'When the running of trains was commenced, mummies were used for Fuel and are said to make a very hot fire – the supply is inexhaustible and they are used by the Cord. What a Destiny! Think of devoting one's existence to providing fuel for a Locomotive'.

Gawsworth eccentric Samuel Johnson lived by the pen rather than the plough. His portrait is included here, as is a photograph of the grave in the local wood that he had chosen for himself and in which he was buried in 1773. Among the other portraits contained in the book are: the Tate Gallery's enigmatic painting of the Cholmondeley sisters; a little caricature by Edward Lear; the unusual miniature of Elizabeth Gaskell by her daughter, Meta; the five daughters of Lee Porcher Townshend of Wincham Hall; and the gallant Trumpet-Major Smith, his chest replete with medals won in Afghanistan and the Crimea.

We have enjoyed putting the book together and hope that the images that we have chosen, documents and photographs alike, will stimulate interest in Cheshire's local history. For some of the images, such as the 1936 Disley air crash, we know quite a lot; for others, such as the launch of the *Santa Rosa*, the Congleton Motor Club on Byley airfield, and the photographs taken by Llewelyn Evans (from the excellent collection at the Salt Museum), we know frustratingly little. Any further information that can be provided for images like these would be gratefully received. Writing a book has been a new experience for us and we apologise for any errors that wait to be discovered. We leave the last word to one of our Cheshire characters, Frances Crompton, a popular writer, talented artist, and keen gardener, who once wrote: 'For after all…what is one but a beginner at the very end'.

one

Buildings

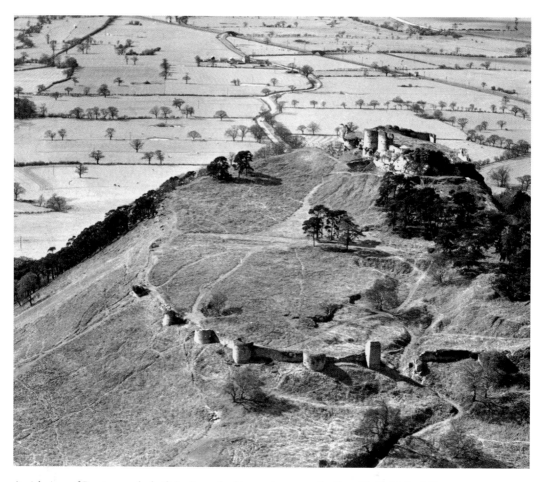

Aerial view of Beeston castle, built in the early thirteenth century by Ranulf, 6th Earl of Chester, following his participation in the Fifth Crusade. The outer bailey and gatehouse can be seen in the foreground, the inner bailey and castle forming a strong defensive position on a rocky outcrop at the top of the hill. With the deep ditch cut through the rock at the entrance to the castle, the twin towers and the solid gatehouses, Ranulf explored new ideas in castle building. Beeston paved the way for the great castles of Edward I that were to come later – Harlech, Beaumaris, Flint, Rhuddlan, Conway and Caernarvon.

Opposite above: Chorley Hall, Alderley Edge. Seen from the old stone bridge over the moat, the original fourteenth-century stone building – one of the oldest inhabited buildings in the county – faces the observer. The half-timbered extension on the right was added by the Davenport family in the sixteenth century.

Opposite below: Like many Georgian landlords who wished to be in the vanguard of aesthetic good taste, the Leicester-Warrens of Tabley altered the areas around their fine house. This 1815 plan for a new lake features many famous names e.g. Botany Bay, the Gulf of Mexico and, seen here, Aboukir Bay – site of Nelson's victory at the Battle of the Nile in 1798. (Ref. DLT 4996/36/1)

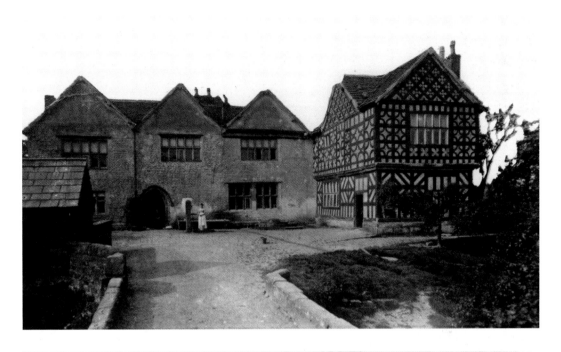

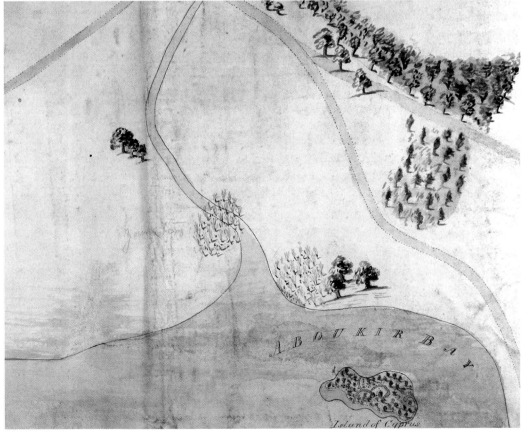

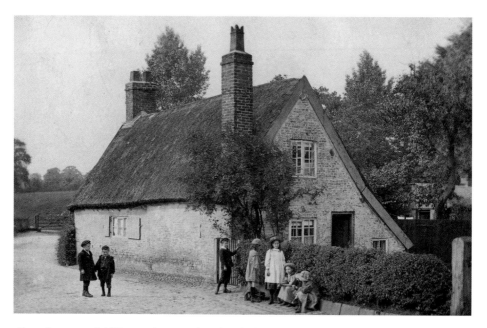

Above: A group of children gather outside a thatched cottage in Mobberley in the late nineteenth century.

Below: The mud and grime of late nineteenth-century industrial Winsford are evident in this view of the High Street. The spire of Christ Church can be seen at centre left, with the chimneys of Hamlett's salt works on the right. Much of the old Winsford High Street was swept away with the introduction of a new road system in the 1960s.

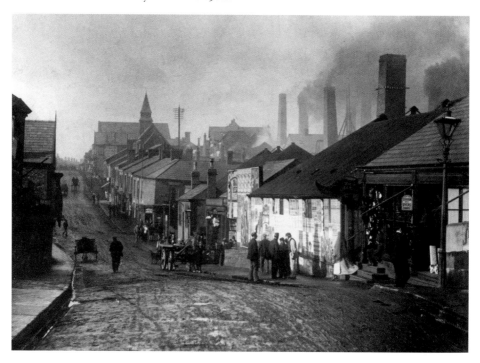

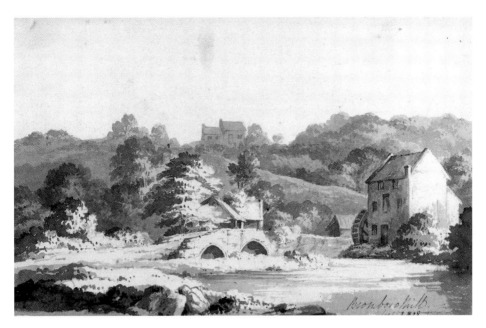

Above: Bromborough Mill on the Wirral, in the autumn of 1828, a watercolour signed 'Congreve'. Miss Marianne Congreve (1780-1871) was the sister of Richard Congreve (builder of Burton Hall) and a keen watercolourist. In 1851 she was living in Bank House, the family dower house for widows and unmarried daughters that overlooked the hall. A formidable and frugal woman, Marianne died in 1871. (Ref. P 195/5638/47)

Below: Was the photographer the novelty attracting these women and children to line up at Four Lane Ends, Antrobus? We may never know. (A Salt Museum photograph)

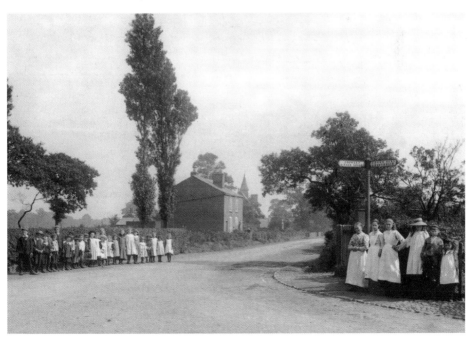

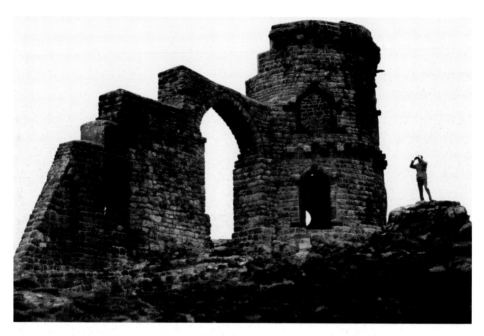

A sentinel on the Staffordshire-Cheshire border, the Mow Cop folly was built by local masons for Randle Wilbraham of Rode Hall in 1754. It was here, in 1807, that large 'Camp Meetings' were held by a group of Methodists led by Hugh Bourne and William Clowes, heralding the birth of the Primitive Methodist movement. The site is now owned by the National Trust.

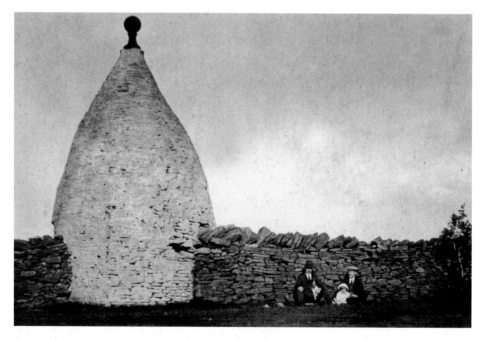

A family shelters alongside 'White Nancy', a landmark on the hills above Bollington, in the 1950s. Several theories have been put forward for the origin of this folly, the most widely supported being that it was put there by a member of the Gaskell family to commemorate the battle of Waterloo.

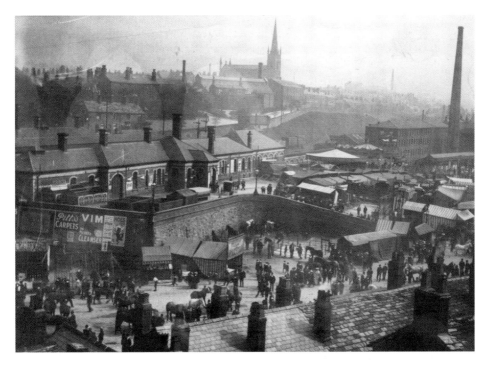

The horse fair in full swing on Waters Green, near Macclesfield station, in the early 1900s. St Paul's church can be seen in the background.

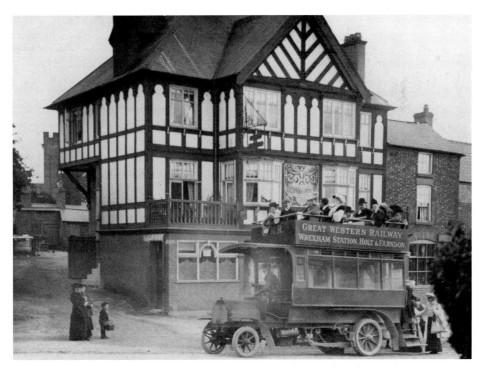

A B-type Great Western Railway omnibus, pictured outside the Raven Hotel in Farndon, *c.* 1910.

Left: Business as usual... The people of
Northwich showed great spirit in coping
with the problems brought by subsidence.
Doors and windows that close properly,
working drains and an uninterrupted water
supply are all things easily taken for granted
today. It was a different story in nineteenth
and early twentieth-century Northwich
when the uncontrolled pumping of brine
had a huge impact on housing, businesses
and public services.

Below: A late nineteenth-century salt
arch in Witton Street, Northwich. The
construction of arches from local materials
was a common focus of public celebration
in many Cheshire towns. The darker base
area of the arch was made from large pieces
of rock salt with smaller blocks of white
lump salt used to create the rest.

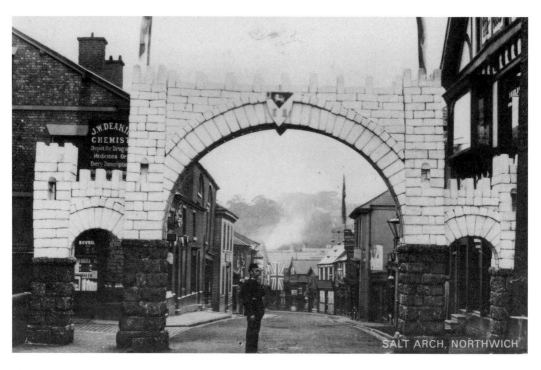

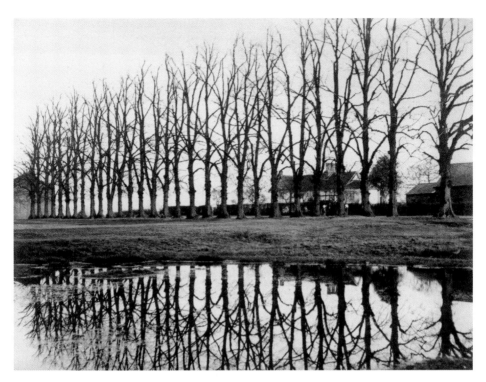

'Row of Trees', taken by T. Baddeley in 1905. This hamlet, near Lindow, is reputed to have taken its name from a row of thirty lime trees planted here in the sixteenth century. The original trees have gone but were subsequently replaced.

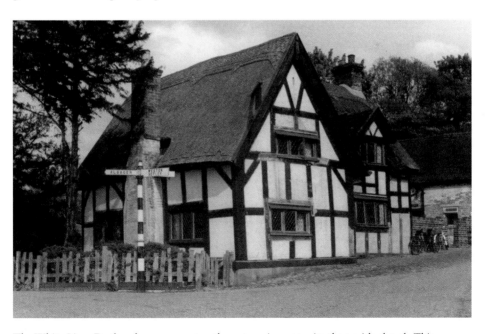

The White Lion, Barthomley – a seventeenth-century inn opposite the parish church. This photograph was taken in the 1950s by Stoke-on-Trent photographer Enoch Booth.

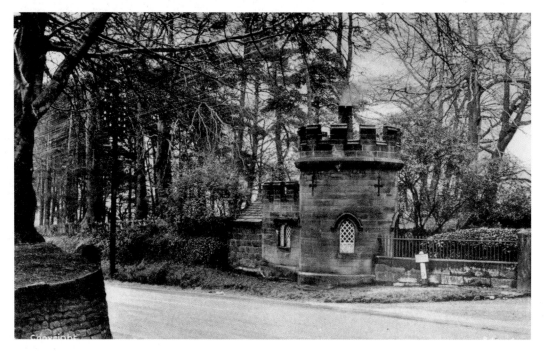

The Round Tower, Sandiway, in the 1920s. This was originally a two-storey lodge for the Vale Royal estate. The gate was to the right of the railings.

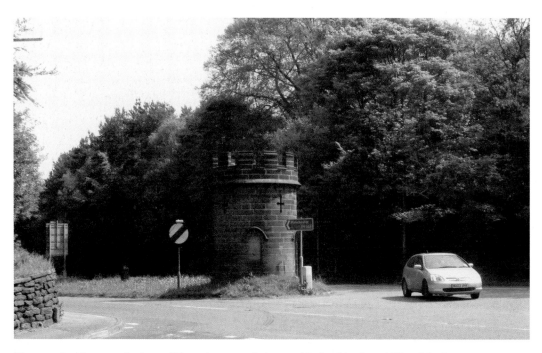

Photographed in 2007, the Round Tower is now sealed up and isolated in the middle of the busy A556 dual carriageway. The room that once extended to the rear of the tower has gone, as has the chimney visible in the earlier photograph.

Education

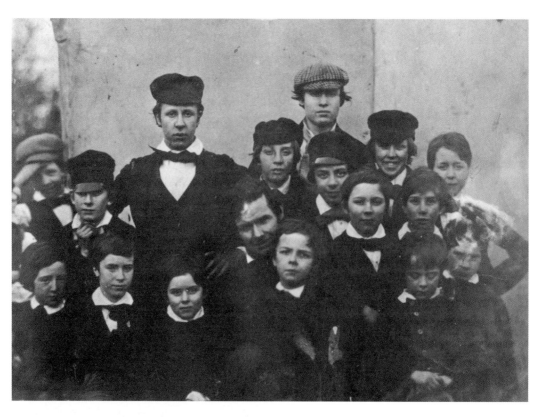

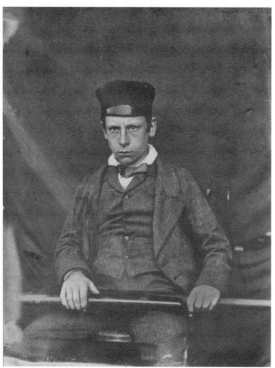

Above: From an album once owned by W. H. Hanmer of Sale, this early school photograph – taken in the 1850s – shows Charles Hanmer surrounded by pupils at his boarding school in Wincham.

Left: Taken around 1850, when cameras were very much a novelty, this photograph shows Master Ferguson, a pupil at Charles Hanmer's school – every inch the aggressive young batsman.

Right: Macclesfield Grammar School was founded in 1504 by Sir John Percival, a local man who became Lord Mayor of London in 1498. The trustees of the school had their own seal, shown here – the impartial master holds knowledge in one hand and persuasion in the other! The letters ER, for Edwardus Rex, refer to the school's refoundation by the boy king, Edward VI, in 1552.

Below: A mid-nineteenth-century watercolour by Master Frank Lee from a book of watercolours, sketches and geometry exercises produced when he was a pupil at Farndon Hall Academy – a 'classical and mathematical boarding establishment for young gentlemen'. The school was owned and run by Dr Henry Armstrong LLD, who taught classics and maths, assisted by his son James. (Ref. D 4828)

crow scaring

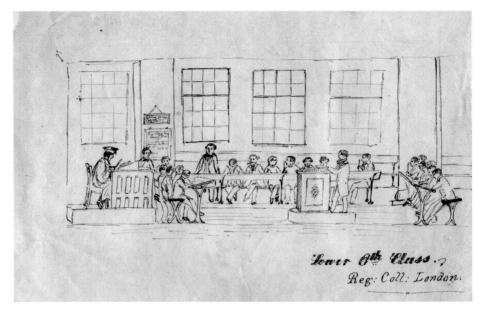

Formal teaching methods – nineteenth-century style. A sketch of the lower sixth class at King's College, London, made by a youthful member of the Davies-Colley family of Newbold (perhaps Alfred), around the 1820s. This is a typical item from the family's papers, which are rich in photographs, drawings, letters and verses. (Ref. DCO 4/25)

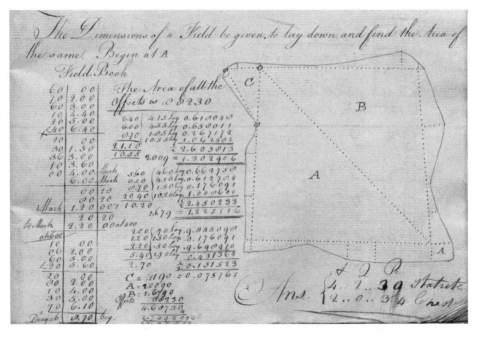

How to measure the size of a field. The late eighteenth-century school books of Peter Dutton show the detailed and exact work of a fifteen-year-old. Many of his exercises seem aimed at providing useful training for a future farmer, which Peter was to become – if a little unwillingly – at Saighton. (Ref. DCO 8/69)

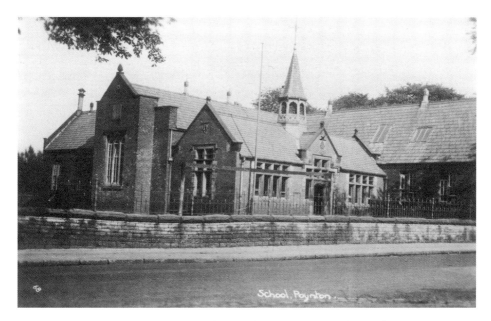

Vernon schools, Poynton, an early 1920s photograph showing various phases of development: the block at the centre of the picture is an 1899 extension; the original 1838 building lies behind it and the long building on the right was an addition made in 1850.

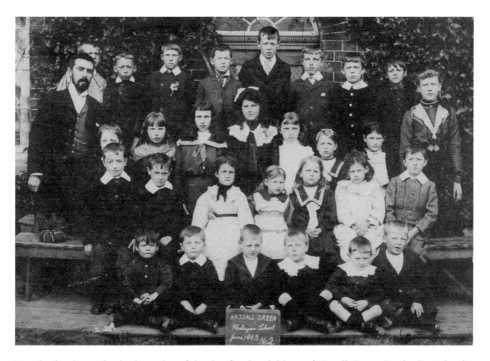

'Sunday best' was clearly the order of the day for the children of Hassall Green Methodist School, Betchton, in June 1903. The school was built in 1858 as a mixed school for 180 pupils. The average attendance at the school in 1902, when John Williams was schoolmaster, was 101.

& sheets, furniture & books (papers burnt), walls & floor, doors & windows, drains & ashpits.

Feb. 17. School re-opened; very bad attendance. Mrs. Bramall sick'd—not being well, the heavy work of last week, has been too much for her, & no outside help was obtainable.

" 19. Wilfred Gallimore, infant of 5 yrs, admitted only a fortnight ago, was placed in a corner face to wall, for scribbling on Writing Copies; he then turned round and blew a whistle in school:—left unpunished as he is one of the "Gallimores" referred to so often in old Log Book (vide same). This boy's sister, 13 yrs old, came to my house & threatened me the same evening. Reports on character of the family may be got from the Log BK., Attend. Officer, or Girls' Mistress.

" 24. Very strong wind from W.; school filled with dense volumes of smoke, even flames issuing from the air inlet of the stove; Managers called in; closed, & reported to Authorities.

" 28. Room has been filled with smoke and sulphur fumes the whole week, at every gust of wind; when very bad I have been compelled to turn chn. out into play-ground in rain or fine; as I write this, the smuts are falling on the page.

" 9. Admitted a boy named Pitchford, from Haslington.

Weston is a small village near Nantwich. In 1908, at the council school for 120 pupils, headteacher Arthur Samuel Bramall described some of the problems he faced daily – poor attendance, staff sickness, inadequate buildings and recalcitrant children. A new boy, five-year-old Wilfred Gallimore, was made to stand in the corner but turned round and blew a whistle. He was 'left unpunished as he is one of the Gallimores, referred to so often in the old log book. This boy's sister, thirteen years old, came to my house and threatened me the same evening'. A malfunctioning stove added to his difficulties – the room 'filled with smoke and sulphur' and 'as I write this, the smuts are falling on the page'. (Ref. SL 251/3924/1)

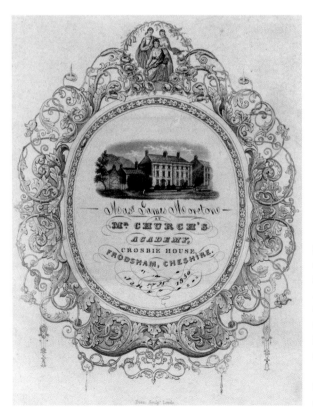

Before Pollard's store appeared at the corner of High Street and Church Street, Frodsham, William Church's Academy occupied Crosbie House, which stood on the site. At the time of the 1851 census, there were seventy-one boys listed at the school, many of them from Liverpool and Manchester. This 1850 bookplate is inscribed by one of the pupils, James Moreton. The school closed in the 1880s. (Ref. D 4828)

One of the school books of a pupil at the Frodsham Academy, thirteen-year-old James Moreton of Moss Hall Farm. Typical of the time, great emphasis seems to have been laid on good handwriting, with the careful copying of pithy and instructive sayings such as 'foment not quarrels and disquietude' and 'Xerxes was valiant but proud'. (Ref. D 4828)

Master Moreton is plainly relieved at reaching the end of his book. After the final line of writing – 'zeal misguided is dangerous' – he adds, in tiny letters, away from the teacher's gaze, 'hip hip hura' and 'Christmas for ever'.

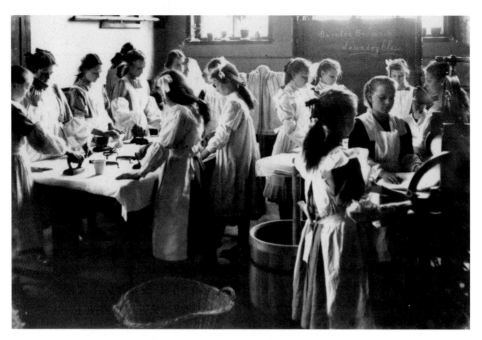

Dashing away with a smoothing iron – Barnton schoolgirls mastering domestic skills in the early 1900s. (A Salt Museum photograph)

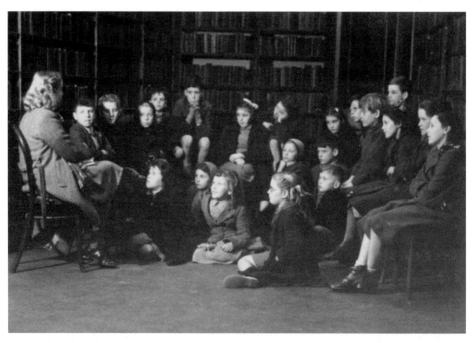

'It was the best of times, it was the worst of times' – storytime in Crewe Library in the 1940s. There is no heating – not unusual for the period – but that doesn't seem to be spoiling the children's enjoyment of the story. In January 1967, the library moved from the Town Hall to a large new purpose-built building in Prince Albert Street, Crewe.

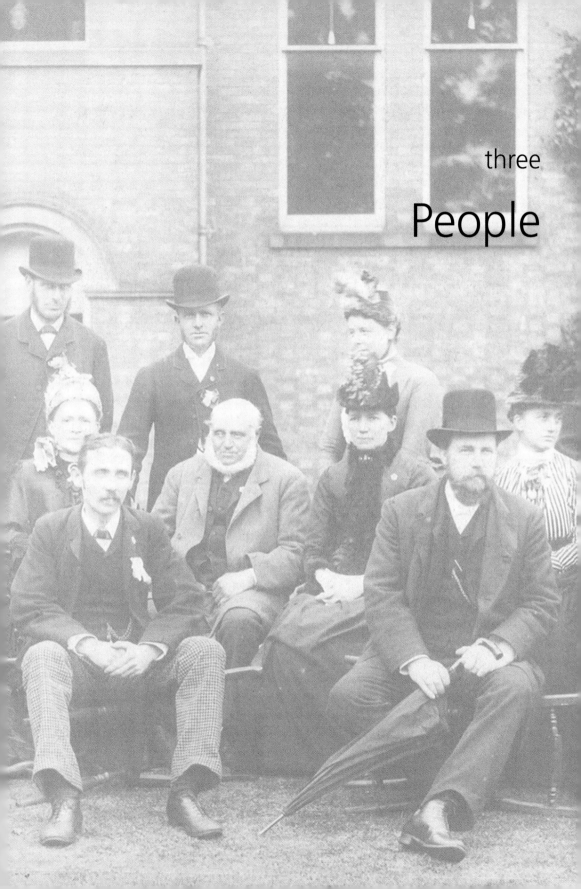

three

People

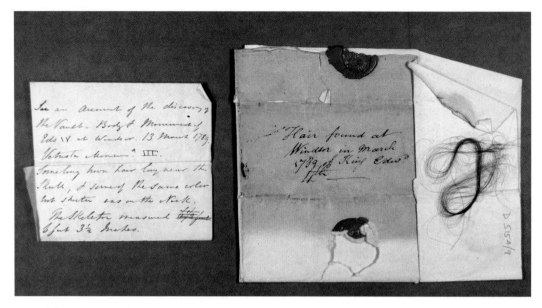

One of the more unusual items held in a collection at the Cheshire Record Office, these strands of hair, alleged to be those of King Edward IV (1461–1483), were taken from a vault at Windsor Castle with a note dated 1789, reporting that 'some long brown hair lay near the skull, and some of the same colour but shorter was on the neck. The skeleton measured 6 foot 3½ inches'. Edward was reputed to be very tall. (Ref. D 5154/9)

A 'Large Bible, 2 Books of Parradice' and 'Mr Milton's Pictures and Coat of Arms' were three of the items listed in the inventory that accompanied the will of Elizabeth Minshull, the daughter of a Cheshire yeoman, who became the third wife of poet John Milton in 1663, when he was fifty-four and she was twenty-five. She nursed the blind Milton until his death in 1674 and survived him for over fifty years, dying in 1727. (Ref. WS 1727)

Louinge mother my humble dutty remenbred thefe are to intreate pardon for
my prefumtion in ftayinge but god knoweth that my defire is to be w.
you therefore good mother benot offended for yefternight I had wrought
w.th my lady to lett me goe home who though unwilling gaue confent
but this morning further talking w. reed by her maides hee
faid if my lady were minded to keepe me I might ftay, if I would,
where vpon fhe abfolutely anfwered I fhould not goe fhe wifth me
w. all kindnes and faith if I will liue w.th her fhe will giue
m. Shakerley my felfe aman and amaide our tables therefore good
mother once more I befech you benot offended for if I had not defired
to come home I would not haue bine foe bould as to fent for hore
I am in good hoope to compafe the diament ring I haue bin foe
long about I haue receiued your bleffing by ned weneright my
this w.th my manyfould prayers to god for your good health I w.th
my fathers crauing both your bleffing for m. Shakerley and my
felfe I humbly take leaue.

Chefter thes iii.th of
July

Your obedient doughter till death

Margaret Shakerley

Above: In 1613, two young Cheshire
gentlefolk left home and married
– Peter Shakerley defied the wishes
of his grandfather-guardian, Geoffrey
Shakerley of Hulme, High Sheriff of
Cheshire, to wed Margaret, daughter
of Philip Oldfield of Bradwall and his
wife Ellen. Here, Margaret's letter of
3 July to her mother mentions that
she soon hopes to acquire a diamond
ring and signs herself 'your obedient
daughter unto death, Margaret
Shakerley'. (Ref. DSS 1/1/30/6)

Right: Lady Mary Cholmondeley
– James I's 'Bold Lady of Cheshire'
– accommodated the young couple
for a while in her Chester house.
She appreciated their 'honest, merry
carriage [demeanour]' and wrote to
Margaret's mother: 'I would all my
sonnes had such wives'.

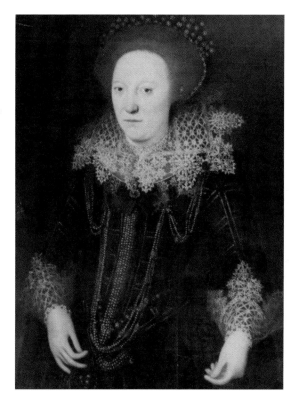

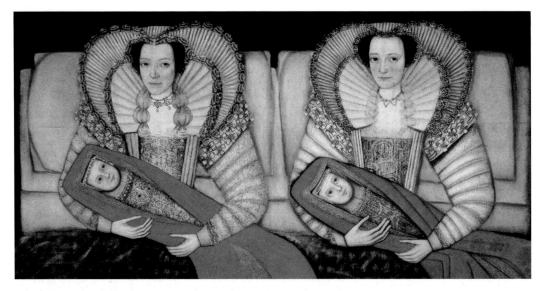

Tate Britain holds this amazing portrait of the Cholmondeley sisters, Mary and Lettice. It was probably commissioned by their mother, Lady Mary Cholmondeley (the 'Bold Lady of Cheshire') in 1606. An inscription on the painting reads: 'Two ladies of the Cholmondeley family/ who were born the same day/ married the same day/ and brought to bed [gave birth] the same day'. There is no known, precise evidence of their birth or child-bearing dates. The younger, Lettice, was married in 1600, a year before her sister. Both women died young, before their mother.

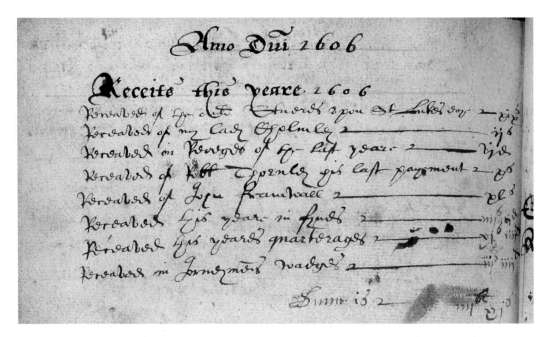

This account from the Chester Painters' Guild, dated 1606, is believed to relate to the painting of the two sisters. The second line reads: 'receaved of my Lady Cholmley iis [2 shillings]'. Another account from the same year carried the line: 'item, spent about the troble wee had with the Lady Cholmley xd [10 pence]'. This may refer to some problem over payment for the painting. (Ref. ZG 17/1)

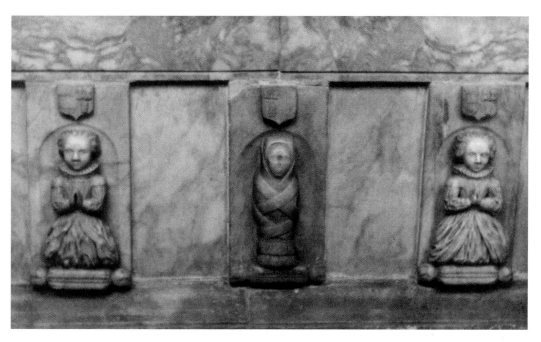

The Cholmondeley family tomb in Malpas church shows the children of Lady Mary Cholmondeley. On the north side are the two sisters, in their early twenties and married. The central figure represents an infant brother.

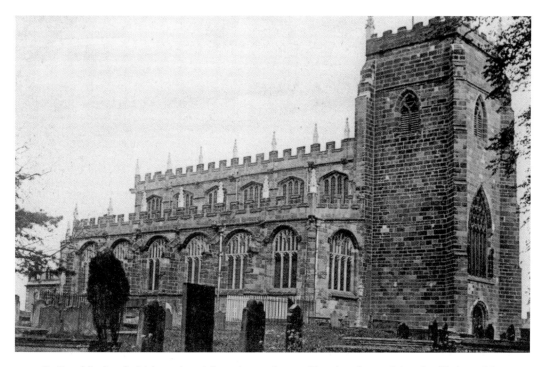

St Oswald's church, Malpas, viewed from the north-west. The chapel, containing the Cholmondeley family tomb, lies at the end of the north aisle, to the left of the picture.

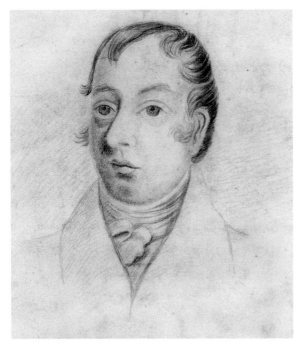

Portrait of Samuel 'Maggoty' Johnson, playwright, dancing master, accomplished violinist and celebrated eccentric. He appeared at the London Haymarket in his own curiously-named play, *Hurlothrumbo*, playing the part of Lord Flame – a title he seems to have decided to retain on his return to Cheshire. 'Maggoty' Johnson lived for some thirty years at Gawsworth New Hall, courtesy of the Earl of Harrington.

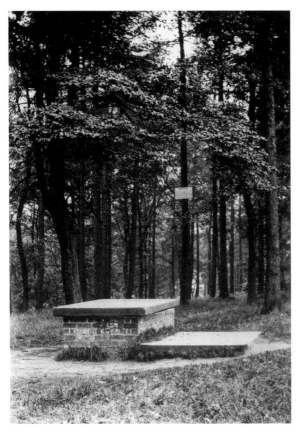

The grave of Samuel Johnson – eccentric to the end. He was buried, at his own request, in woods on the Harrington estate in 1773. The site is now managed by the National Trust.

Right: In this letter of 1766, Sir Peter Byrne Leicester of Tabley Hall, near Knutsford, writes concerning his brother, John Byrne Leicester, who had taken up with the pretty daughter of the landlord of The Angel hotel in Knutsford. Sir Peter claims she is a whore and if his brother makes off with her to Gretna Green he will forfeit any rights to the estate, 'a jail will be his end'. (Ref. DLT 4996/28/6)

Below: The Angel hotel on King Street, Knutsford, where John Byrne Leicester was so struck with the landlord's daughter. This photograph was taken in the early 1900s.

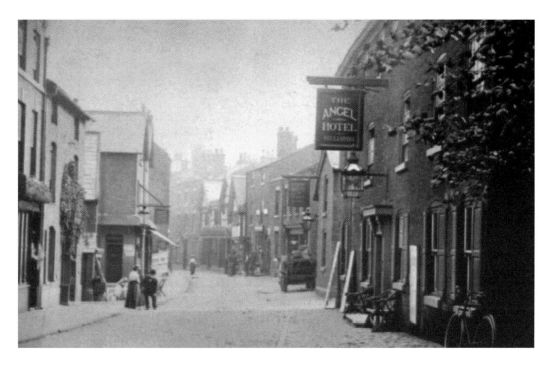

_"warrant, & properly justify." She frankly acknowledges
her previous Intentions was, to incorporate in her Letter
a Subject, she has avoided touching upon. Surely
some insidious Foe, (to my Happiness at least) must have
been at her Elbow, dictating Expressions as I conceive
would not otherwise have emanated from her tender
and loving Breast. The Idea of a lame Person
Hobbling on a Stick by the side of —— when going
up to the Hymeneal Altar has I confess so much of
the ludicrous and grotesque attached thereto, as would
be rather revolting to the Minds of some. But as it is
a mere fanciful Exhibition, existing only in Imagination
I am truly grieved to perceive that such a Nonentity
has been permitted so to operate on the Mind of My
Dear Mary, as seemingly, to determine her Hesitation
about acceding to my Wishes. Suffer a Word of Exhortation
my Dear, and be not hastily carried away with false
Representations, Give to a Matter of such Importance
its due Weight of Consideration, and let not the short_

A bundle of letters, written in the 1820s by farmer Peter Dutton of Saighton Hall to Mary Meredith of
Coddington Hall, hints at an unrequited passion. Peter, aged about fifty, was a melancholic and in poor
health. Mary, aged twenty-seven, had been orphaned at nineteen. He was in love; she was not. She found
his stoop and his 'improving' nature a trial but seemed unable to make a definite decision. She had a fear
of childbirth, her eldest sister having died this way, aged thirty-two. Mary wrote of 'various irremovable
obstacles' to their union and, eventually, asked for the return of her letters. Coddington's registers contain
no marriage entry for her and she was buried in the churchyard there in 1834, aged forty-one. Peter
lived to sixty-seven and was buried at Bruera in 1837. Strangely, he left no will, although his estate was
worth £3,000, a considerable sum at that time. (Ref. DCO 9/80)

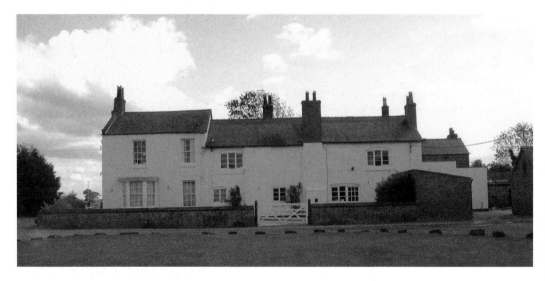

A recent photograph of Saighton Hall Farm, once the home of Peter Dutton.

I have been guilty of Malice, hatred, and revenge, and tho' I have never murdered any person, yet how oft have I wished their Death. Lord, thou knowest, I have suffered Anger, and passion to reign in my deceitful heart and shew them upon every sligth Occasion. I have very often been in most violent Passions when contradicted by my Parents. O how have I cursed and swore, called upon thee to damn every thing around me. when bid to do any small matter contrary to my will. how have I suffer'd Passion to rage in my breast against my Fellow Creatures upon the least provocation, my heart has been filled with Malice and hatred against my C——n I have very ill natured with my little Sister, instead of giving her an Example of Brotherly Love, & being kind to her. I have very often thwarted her, raged against her, & took a sort of Pleasure in vexing her. My sins against thy 6 Command are innumerable

Were I to set down an account of my sins against the 7 Command I should be at a great Loss to reckon up one thousandth part of them I can only say that every Day have I been more or less guilty both in thoughts, Words, and Deeds, which plainly shew that my heart is (as it were) a Magazine of Wickedness quite unclean & impure, & transformed into the very Image of the Devil. I have several times acted in a very shameful Manner, and tho' I never committed Adultery with any one, yet how have I secretly enjoyed them, which was as sinful in thy sight as if I had been really guilty. I have sinfully coveted to enjoy — how has my heart burned with Lust sinfully to enjoy a Person, who appeared fine in my Eyes Unchaste & wanton Thoughts have found great Encouragement, & been suffered to dwell in my sinful heart, I not at all endeavouring to put them out.

Above: This minor masterpiece of self-loathing is in the form of a diary, describing the writer's struggle to control his anger and disobedience, his breaches of the sixth and seventh commandments, his hatred of his cousin, his cruelty to his little sister and his secret enjoyment of other men's wives while his 'heart burned with lust'. The author is believed to be either Thomas Clubbe of Newbold (1753-1776), who died soon after graduating from university, or Peter Clubbe (1755-1844) – a local patriarch of uncompromising morality in his later years. (Ref. DCO 3/84)

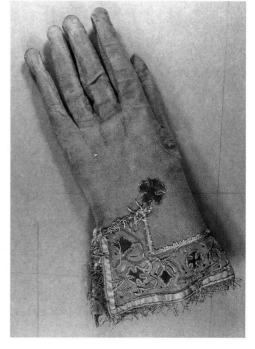

Right: One of the more unusual items in Cheshire's archives, this lady's riding glove in soft leather was said, by a later owner, Miss Irene Coneybeare, to date from around 1680. It was found with a tag inscribed 'Markland'. The papers of the Markland (of Wigan) and Coneybeare (West Country) families came into the possession of Arnold Whitworth Boyd, a naturalist and antiquarian who lived at Frandley House, Antrobus from 1920. (Ref. D 5154)

bread. We have now a great variety
of vegetable productions at table, musk
mellons, water mellons, pumpkin and
squash pie, fried egg-plant, tomatoes.
besides the common English vegetables.
- I forgot to mention boiled green corn
(maize) which is very fine, the mode
of eating this seems somewhat strange
to a new comer. The cob is buttered and
then firmly clutched in both hands —
It is then raised to the level
of the mouth and the teeth
are applied and quickly
traverse from one end of the
cob to the other removing two
longitudinal rows of corn
and depositing the result in

Dr Thomas Alcock of Oaklands, Ashton upon Mersey, was a lecturer at Owen's College, Manchester. He kept a diary to help his partially-deaf wife learn more about their household. This copy of a letter from his brother Samuel in Illinois describes how the locals ate corn on the cob. A later diary records his wife's death on 25 March 1852, after 6,339 days of marriage, and carefully logs the days of his 'separate journey' without her. (Ref. D 6817)

HOW TO COOK A HUSBAND.

As Mrs. Glass said of the hare, you must first catch him. Having done so the mode of cooking him, so as to make a good dish of him is as follows:— Many good husbands are spoiled in the cooking; some women go about it as if their husbands were bladders, and blow them up. Others keep them constantly in hot water, while others freeze them by conjugal coldness. Some smother them with hatred, contention and variance, and some keep them in pickle all their lives. These women always serve them with tongue sauce. Now it cannot be supposed that husbands will be tender and good if managed in this way. But they are, on the contrary, very delicious when managed as follows:—Get a large jar, called the jar of carefulness, (which all good wives have on hand) place your husband in it, and set him near the fire of conjugal love; let the fire be pretty hot, but especially let it be clear—above all, let the heat be constant. Cover him over with affection kindness, and subjections, Garnish with modest, becoming familiarity, and the spice of pleasantry, and if you add kisses and other confectionary, let them be accompanied with a sufficient portion of secrecy, mixed with prudence, and moderation. We would advise all good wives to try this receipt, and realise how admirable a dish a husband is when properly cooked.

Odd things are always turning up in archives. This cutting on 'cooking a husband' was found in a nineteenth-century account book. (Ref. DDX 183)

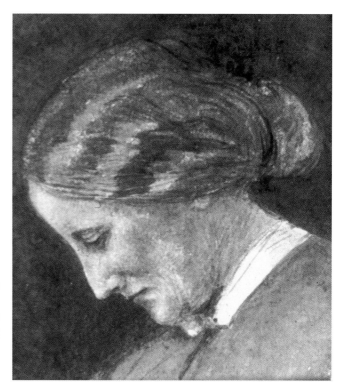

The lady who put Knutsford on the map: a small (6.5cm square) watercolour of Elizabeth Gaskell by her daughter Meta. An inscription on the back reads, 'I cannot tell you how much I wish that this were better. But nothing could ever give <u>her</u> face'. It was painted in around 1866. (Ref. D5437)

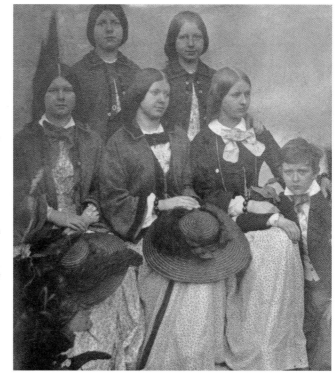

Taken in the 1850s – with Master Hoolier – an early portrait of the five daughters of Lee Porcher Townshend of Wincham Hall. In 1855, Harriet was twelve, Emily fourteen, Cornelia fifteen, Fanny eighteen and Mary twenty. Reminiscent of Jane Austen's Bennett family, all were to be married off except Mary – Fanny to William Congreve Esq. of Burton in 1862; Cornelia to Captain Stewart of the Bengal Army in 1861; Emily to Edward Logan in 1865; and Harriet to Revd H. Hitchings in 1875.

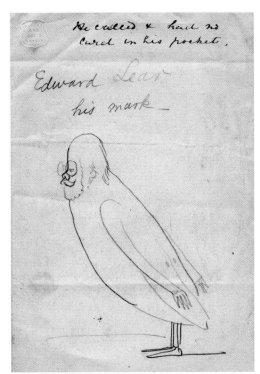

Left: Found among the Markland papers in the A.W. Boyd collection, this autographed caricature of (and by) Edward Lear is inscribed: 'he called and had no card in his pocket'. An artist and writer, Lear once gave drawing lessons to Queen Victoria. In 1846, he published his famous *Book of Nonsense*, which he had written for the grandchildren of the Earl of Derby. (Ref. D 5154/8)

Below: 'Primrose League' members from the Congleton area in the late nineteenth century. Set up as a right-wing group in the 1880s, the league was named after Disraeli's favourite flower. At its height in the 1890s, it had over a million members and it remained in operation until it was finally disbanded in December 2004.

A popular writer of children's books in the late nineteenth century, Frances E. Crompton (1866-1952) spent much of her life in Wilmslow and Chelford. An accomplished artist and keen gardener, she enjoyed several trips to Europe, recording her observations in neatly written diaries. She writes of Amsterdam in the summer of 1892, 'we have just come up from dinner... there have been some very offensive foreigners at table, who have smelt their wine, picked their teeth, stared, talked loudly, ordered the waiters about, drunk a good deal of wine, and otherwise made themselves agreeable to the general public'. Frances E. Crompton died in 1952 and is buried in Chelford churchyard.

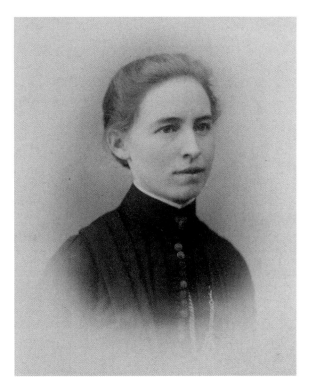

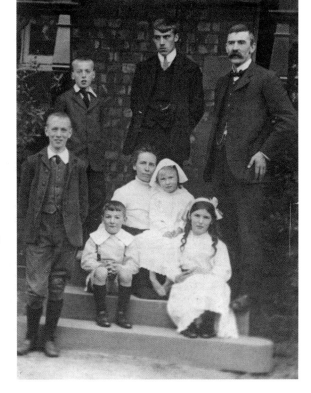

Frances E. Crompton, surrounded by her family in 1911. Standing left to right: sons Geoffrey (posted missing in 1917); Roger (died 1974); Arthur, a teacher at Chester's King's School (died 1992); and husband Leo Walsh, a bank manager, (died 1950). Sitting left to right: John, a Cheshire clergyman (died 1988); Frances (died 1952); Gwenifer, an accomplished musician (died 1999) and Audrey, a local historian (died 1998).

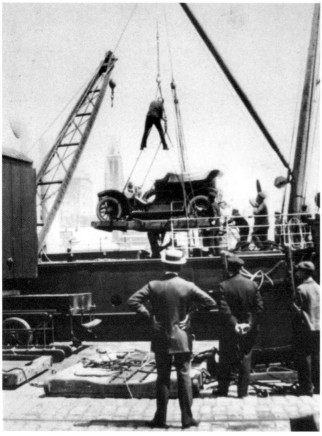

Above: The Dickens family, a photograph taken in Great Budworth by the Winnington photographer Llewelyn Evans in 1904. (A Salt Museum photograph)

Left: Travelling with his wife Mary Ann (nicknamed 'Puss') in a car they called 'Miss Berliet', Sir Percy Elly Bates, a Liverpool shipping magnate of Hinderton Hall, Neston, kept a diary of the couple's 1908 tour of France, Spain and Portugal. He logs only two punctures on the rough trek between Lisbon and Boulogne, where the car was winched on board, but notes some problems with local food and culture, at one point having to threaten difficult locals with a horse-whip. Sir Percy died in 1946 though Mary Ann lived on until 1973. (Ref. DDX 442)

four

Employment

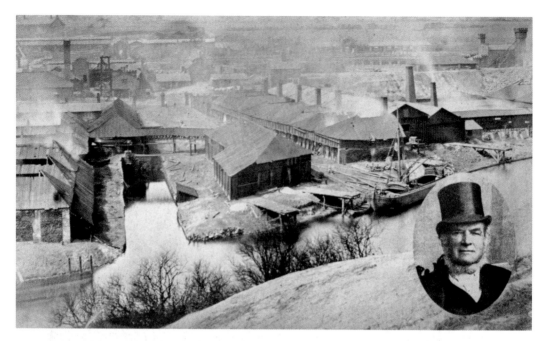

Meadowbank Salt Works, Winsford, in 1864. This rock-salt mine was established in 1844 by Herman Eugene Falk (inset), a Danzig-born entrepreneur. Originally a timber merchant, Falk became a powerful and influential figure in the mid-Cheshire salt industry.

The devastating impact of subsidence on the salt-mining area north of Northwich in the late nineteenth century.

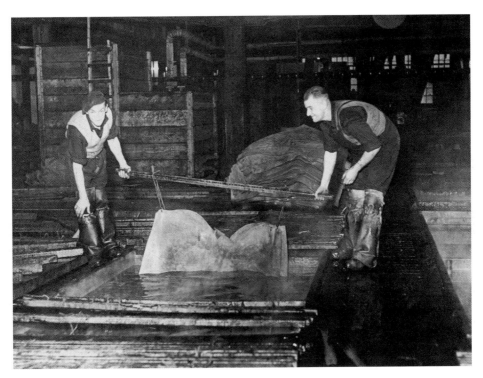

Dipping hides at the Highfield Tannery, Runcorn, in the 1960s. A growing population and large demand from the military once sustained a thriving tanning industry in towns such as Warrington and Runcorn. The switch from leather to modern synthetics in shoe production hit the industry hard and Highfield Tannery closed in 1968.

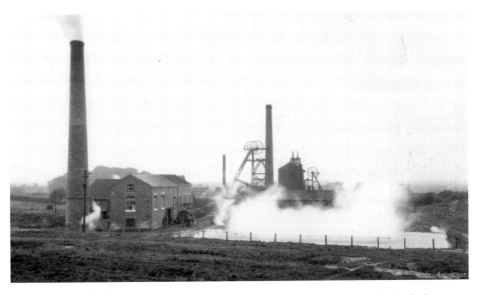

Park Pits, Poynton in 1926. Cheshire was never a significant producer of coal. Much of what was produced came from the collieries in Poynton and Ness, which closed in 1935 and 1927 respectively.

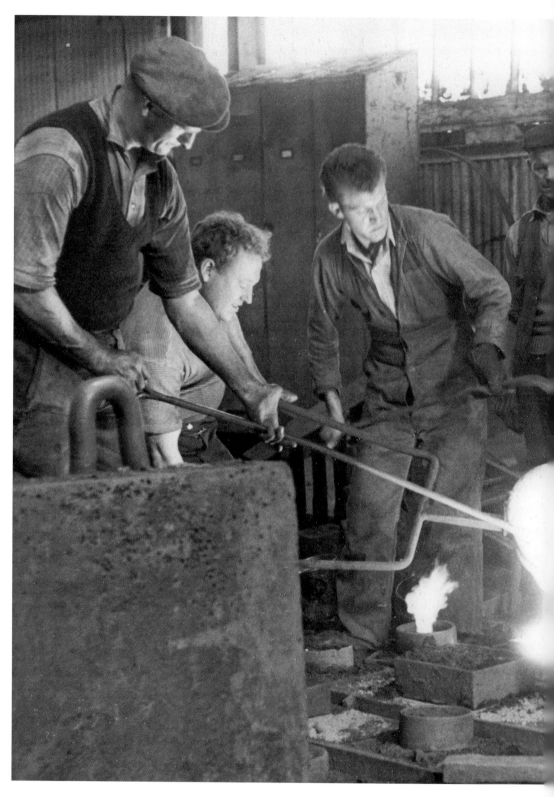

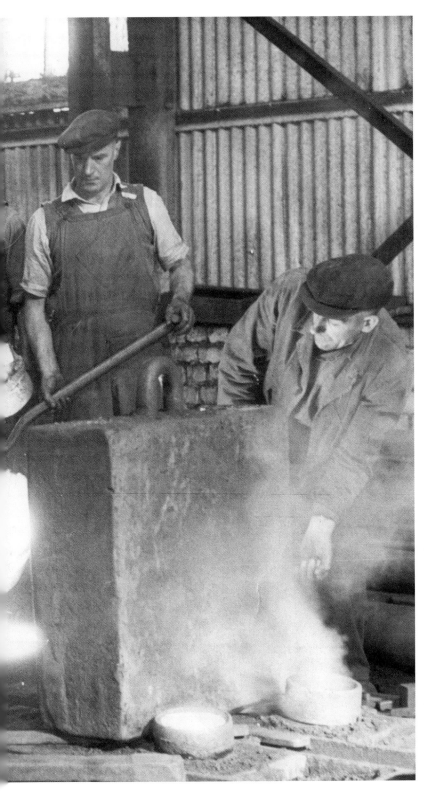

In the style of an eighteenth-century painting, workers at Henry Bates & Sons Ltd of Northwich cast iron pipes at Witton Foundry in 1963. Left to right: Harold Robinson, Derek Senior, -?-, -?-, Frank Robinson, and Stanley Rowlinson. The man third from the left is holding a small ladle for 'topping off' the cast. The large square weights visible to the left and right weighed 2 tons each. (Ref. DDX 543/8)

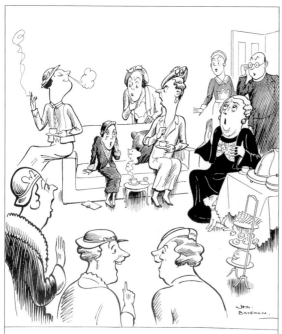

The woman who said she had never heard of the Radiation "New World" Gas Cooker

A cartoon by H.M. Bateman showing how 'New World Appliances' used a famous talent to establish its brand as a household name in the 1960s. The company developed from an earlier venture in 1890 at Thelwall near Warrington. Surviving archives include minutes, accounts, photographs and publicity material relating to stoves, cookers and fires. (Ref. D 7141/240)

Gas cookers on the production line at Richmond's works. A Warrington gas engineer, W. Unsworth, joined with Richmond Ltd in 1890 to form the firm of Richmond & Co. In 1901, the business moved to Grappenhall and acquired the assets of G. Glover and G. Newton. Several name changes, takeovers and decades later, the firm was acquired by Glen Dimplex Group in 2000.

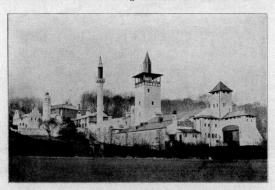
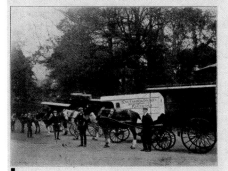
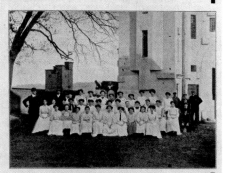
Mediterranean-style domes, towers, and minarets were very much a feature of the work of the artist Richard Harding Watt. He built the laundry on Drury Lane, Knutsford, in 1900. A follower of Ruskin and a firm believer in enlightenment for the working man, he added the 'Ruskin Rooms' for the recreation and education of the laundry workers at the top end of Drury Lane in 1902. This advertisement for the laundry appeared in 1906.

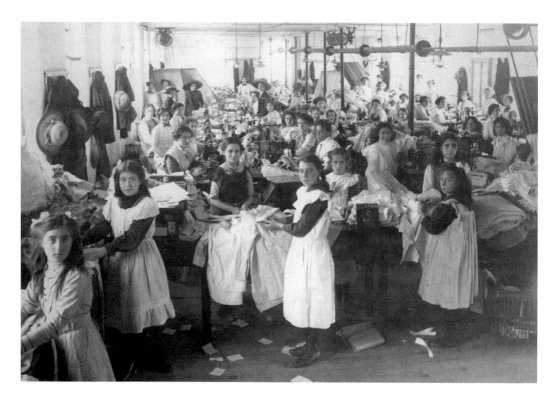

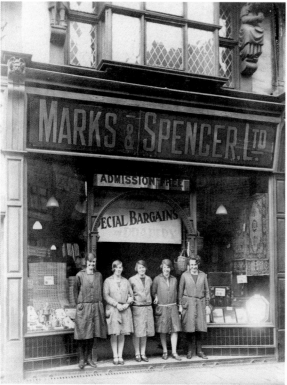

Above: Women and young girls working at Clapham's shirt factory, Henderson Street, Macclesfield, in about 1912.

Left: Shop assistants line up at the first Northwich branch of Marks & Spencer Ltd, which was in Northwich High Street. M & S later moved further up the High Street, next to Woolworth's store, before transferring to their present site in Leicester Street.

Diarist Thomas Millan, a Cheshire farmer, left Tilstone Fearnall with his wife and daughter for a new start in North America in February 1855. He bought a 120-acre farm in Newport, Iowa for £172 in April 1855. From the beginning, they found winter conditions in Iowa hard to cope with. 'The severity of the weather here in the winter season is beyond all conception,' Millan wrote. 'I have seen the cups and saucers frozen together, in two minutes after being used'. (Ref. D 1276 A)

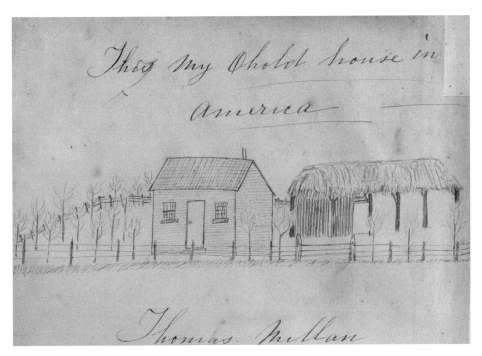

Thomas Millan left this drawing of his 'C[h]old house in America', a small house he had built on his land for $25. By August 1856, he had had enough. Facing the prospect of another cold winter, Thomas sold his farm to an Irishman for $1,300 and returned to England with his family in June 1857.

Burton sheep farmer James Kemp with two sons behind, Charlie on the left and William on the right. James's father was a noted Lincolnshire wildfowler known as 'Billy th' Duck', who brought his punt with him when he moved to the Wirral. This photograph dates from the early 1900s.

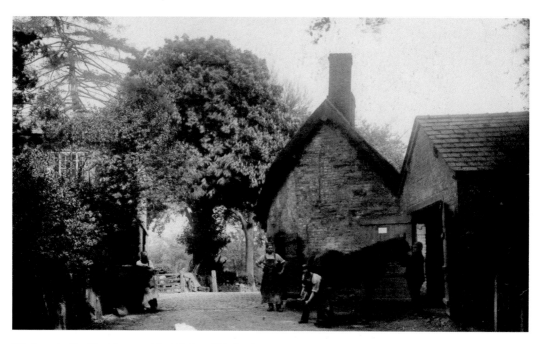

Work at the Bradford Lane smithy, Nether Alderley, in 1896.

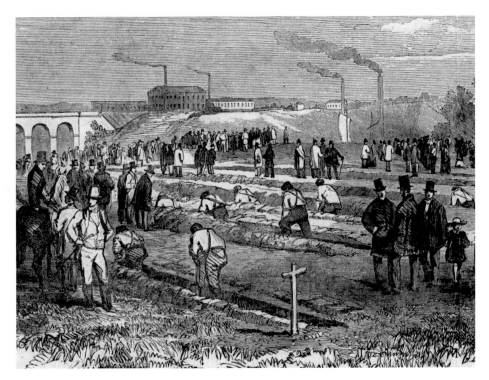

A 'great draining match' was held on Samuel Brooks's Burtonwood estate in November 1853, attracting competitors from all over the North West and a large crowd of onlookers. This illustration comes from a report in *The Illustrated London News*.

Something of a mystery – a woman with child, dog, chickens and wheelbarrow, on a smallholding believed to be in the hills above Macclesfield. It would be nice to know who she was and the details of where and when the picture was taken… perhaps one day we shall.

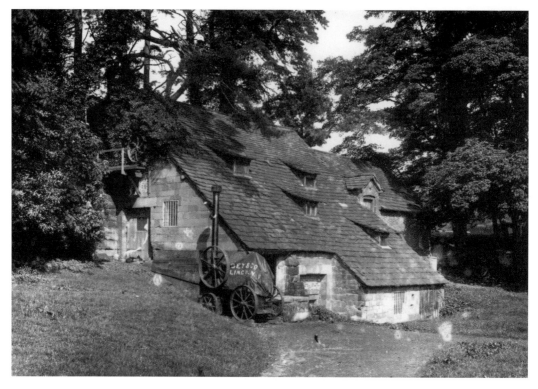

This fifteenth-century corn mill at Nether Alderley has been operated by the National Trust since 1950. The stone flags on the roof, clearly shown in this photograph, are said to weigh about 200 tons.

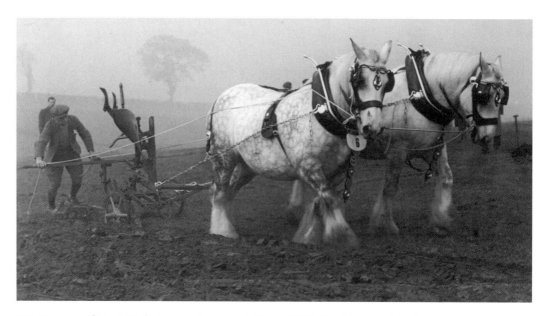

H.J. Mosscrop of Great Warford competing in an Adlington YFC ploughing match in the 1950s.

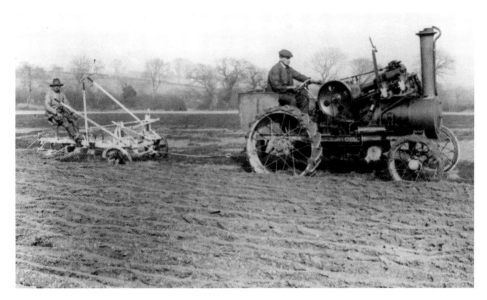

An 'Agri-tractor', built in 1928 by Fodens of Sandbach, towing a plough. The Foden archive at the Cheshire Record Office contains many good-quality images of the early steam wagons, traction engines, lorries and buses produced by the company.

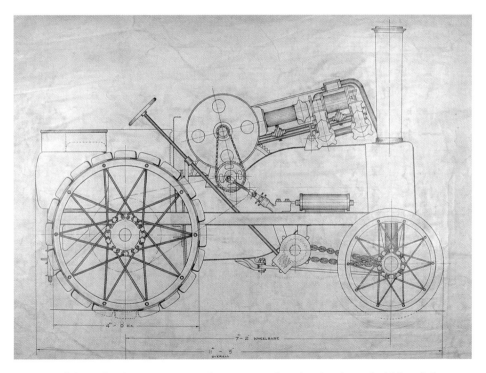

Drawing of the Foden Agri-tractor, one of over 200 engineering drawings of vehicles of all types – early steam wagons, tractors, diesel lorries etc – in the Foden collection at the Cheshire Record Office. (Ref. DFO)

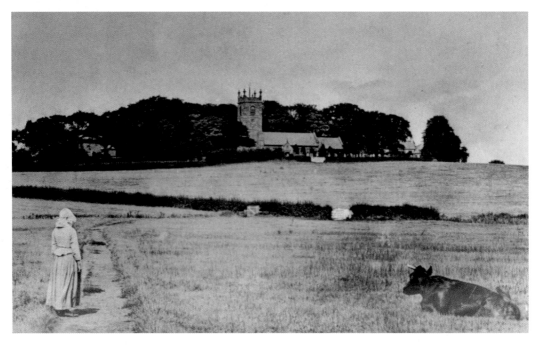

A timeless rural landscape at Great Barrow. The church on the hill, dedicated to St Bartholomew, dates from the seventeenth century onwards, but thirteenth-century documents confirm the existence of an earlier church in the village.

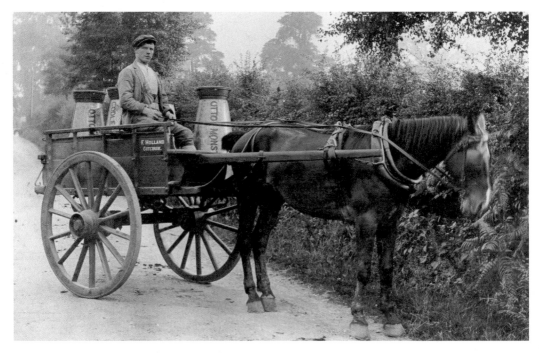

Milk delivery from the Holland family of Cotebrook, Utkinton. Trade directories of the early 1900s list John Holland of Utkinton Lodge as a farmer and miller.

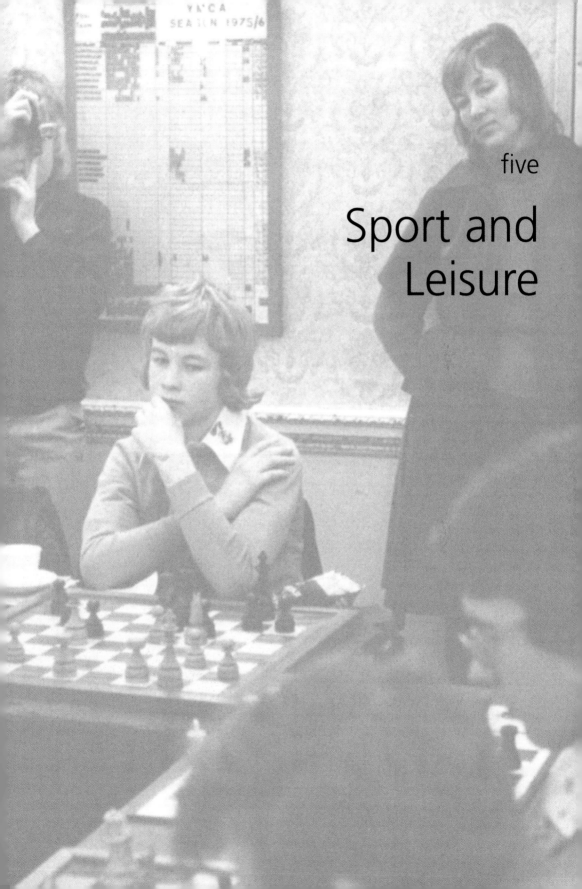

five

Sport and
Leisure

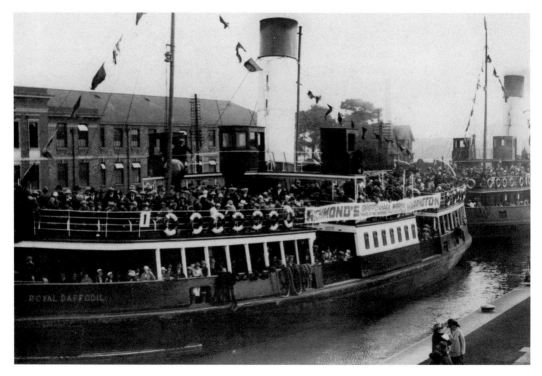

Works outings in the 1920s and 1930s could be big affairs. Here we see an outing to New Brighton from Latchford Locks in 1923 for 2,000 employees of Richmonds Gas Stove Co. Ltd on the Wallasey ferry boats, the *Royal Daffodil* – once famously employed on the commando raid to Zeebrugge in April 1918 – and the *John Joyce*.

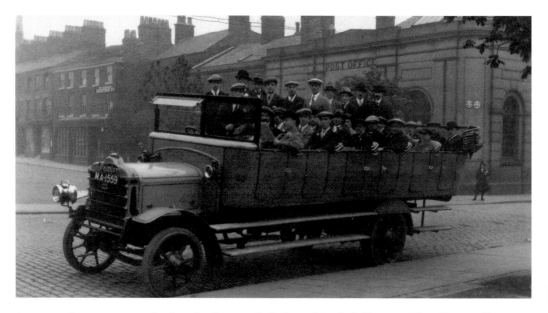

A group wait to go on an outing in a charabanc on Park Green, Macclesfield, *c.* 1920. The old post office, on the corner of Sunderland Street, can be seen in the background.

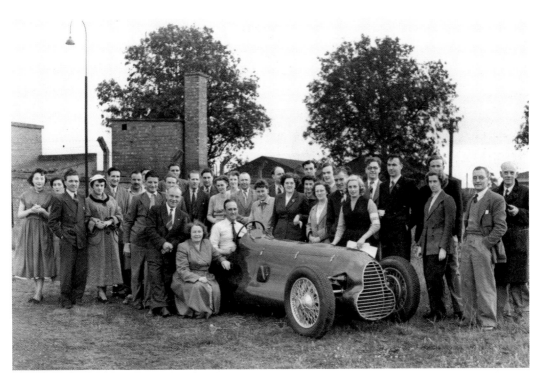

Congleton Motor Club on Byley airfield in the 1950s, surrounding what looks like an Alfa Romeo racing car.

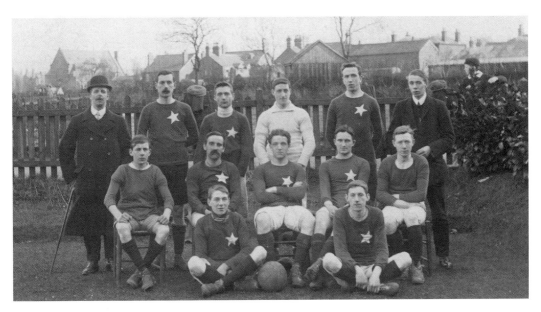

No doubt the star players in Alsager's Red Rovers football team are in this photograph, taken some time between 1910 and 1920.

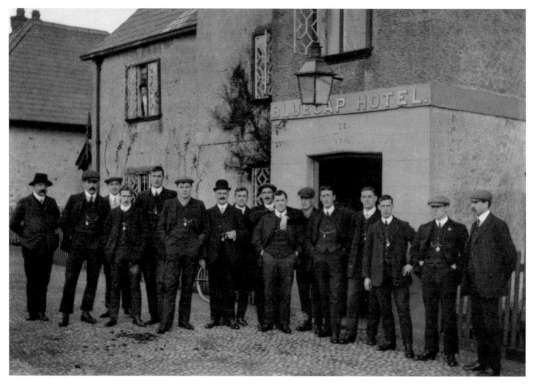

Manchester United football team outside the Blue Cap, Sandiway in 1909. (A Salt Museum photograph)

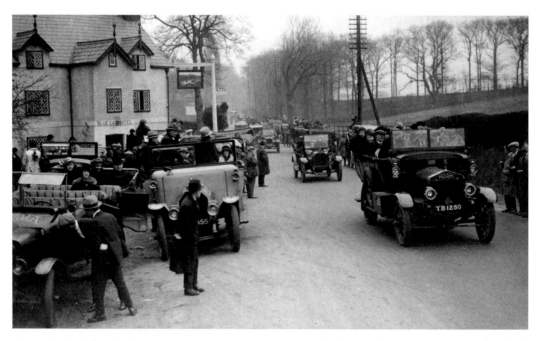

The same place, but a different time and a different sport... crowds gathering at the Blue Cap for the Tarporley Hunt Races on 4 April 1925.

Right: This letter of 1915, on professional headed notepaper, from Billie Hughes to Lord Cholmondeley, notes the 102nd birthday of Nanny Turner, whose candy shop Billie patronised as a schoolboy, and expresses his desire to contact his old school chums. Hughes's formidable fight record included twenty-one knock-outs. In 1915 he had never been beaten at his own weight. (Ref. DCH/X/21)

Below: The old-style stick and full regalia for the Widnes ladies' hockey team of 1914/15.

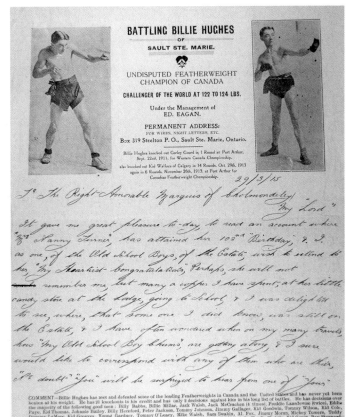

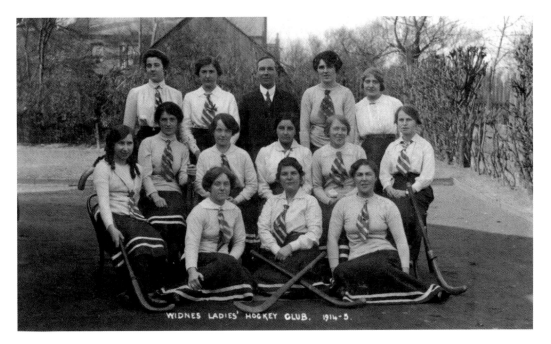

WIDNES LADIES' HOCKEY CLUB. 1914-5.

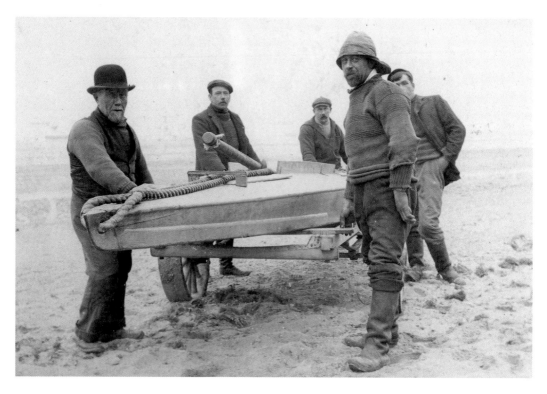

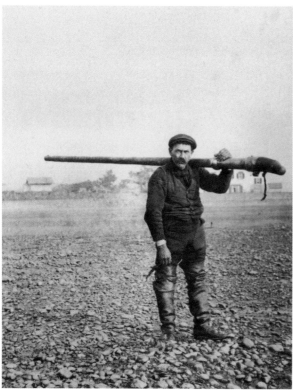

Above: The Evans family of Heswall with a wildfowling punt in January 1907.

Left: Tom Evans with a 120lb (54.4 kilos) punt gun – 1½ inch bore, usually firing about a pound (0.45 kilos) of shot. He spent his summers as quartermaster on the *Mauretania* and *Lusitania* and drowned when the *Lusitania* was torpedoed off Kinsale, Ireland, on 7 May 1915.

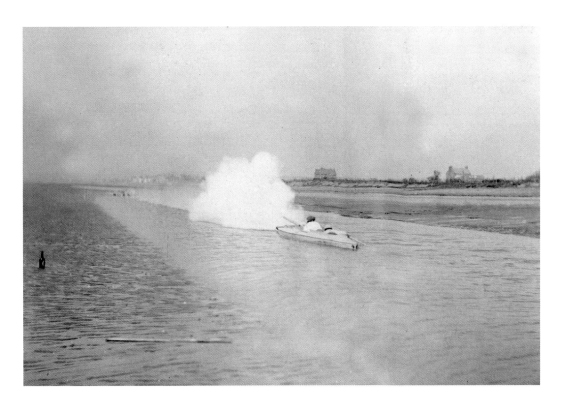

Above: The moment of truth. After what was usually a lengthy wait, the two wildfowlers concealed in their punt fire a shot at duck in the Parkgate gutter. The muzzle tended to jump on firing and the recoil was partly absorbed by ropes looped under the barrel.

Right: John Byrom's estate and domestic account book includes this pasted-in notice-cum-recipe for a special mixture – nitrate of potash, water, tobacco and cayenne pepper – for persuading rabbits to leave their burrows. Unusual for an account book, it contains newspaper cuttings, poems, and photographs. (Ref. DDX 183)

To take Wild Rabbits alive.

APPROACH the Warren or Holes very quietly, and place a small purse net, the same as are used for ferreting, over the mouth of each hole, then put a common tobacco pipe full of the preparation hereafter named into the mouth of each hole, *always* on the *windward* side of the Warren only, and ignite it with a lucifer match, and after ignited close up the opening.

To make Rabbits bolt for Shooting.

PUT the same quantity of the preparation in the opening of the holes, on the *windward* side of the Warren only as above directed, and stand perfectly still in some convenient place on the contrary side, when you may secure good sport by shooting the rabbits as they leave their holes.

THE PREPARATION IS MADE THUS:

Dissolve two drachms of *Nitrate of Potash*

in one ounce of *Water*

then wet one ounce of *Tobacco*

with the Solution, freely sprinkling it with half a drachm of

Cayenne Pepper Let it dry

very gradually in the sun, or by a very slow fire, when it will be ready for use.

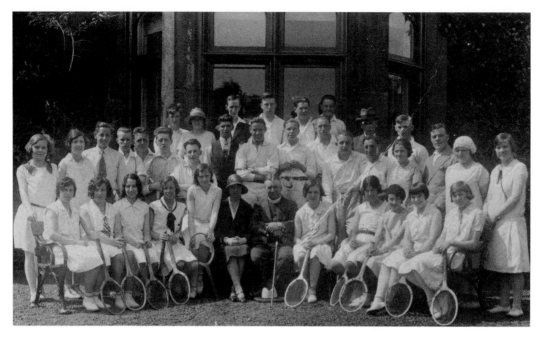

Leisure – 1930s-style. This picture shows St Mary's tennis club, Sandbach, in 1930.

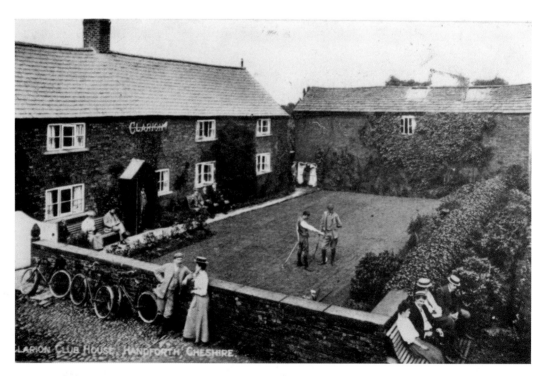

Cyclists gather at the Clarion Club, Handforth, *c.*1910. The Clarion Club was formed in 1894 with the twin aims of spreading interest in cycling and the benefits of socialism.

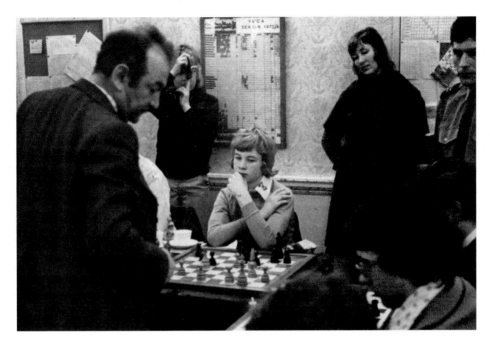

Viktor Korchnoi played a simultaneous display on twenty-five boards at the Chester YMCA chess club in 1975/76, scoring twenty-two wins, one draw and two losses (to Messrs Bullard and Townsend). Born in 1931, Korchnoi was a Russian chess grandmaster, strong enough to challenge for the world championship in 1978 and 1982. On both occasions he lost, controversially, to Anatoly Karpov. (Ref. LOX 11/13)

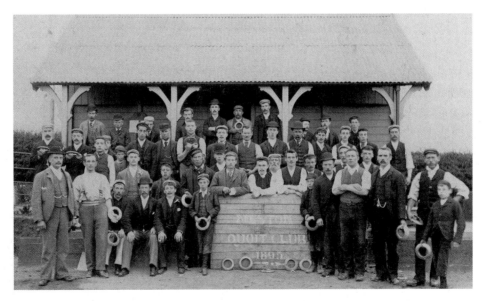

Neston quoits club in 1895. The club was started, off Raby Road, by the Revd William Barrett as an alternative to the 'demon drink' for the working man. Not unlike bowls in its method of play, quoits was for many years a popular pastime in the North of England. Pitches varied in length and the quoit could weigh anything from 2 to 14lbs.

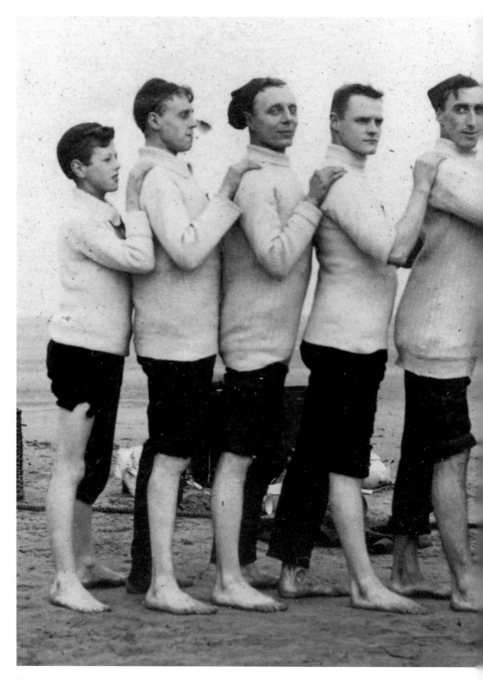

'You put your right leg out…' New Brighton Wesleyan Boating Club 'chorus line' out on Burbo Bank in the Mersey estuary in 1912. The club rowed at least fourteen miles every Saturday to places such as Eastham or the Crosby Lightship and was not for the faint-hearted: 'if you are not out and out fond of work and water, don't join… if you

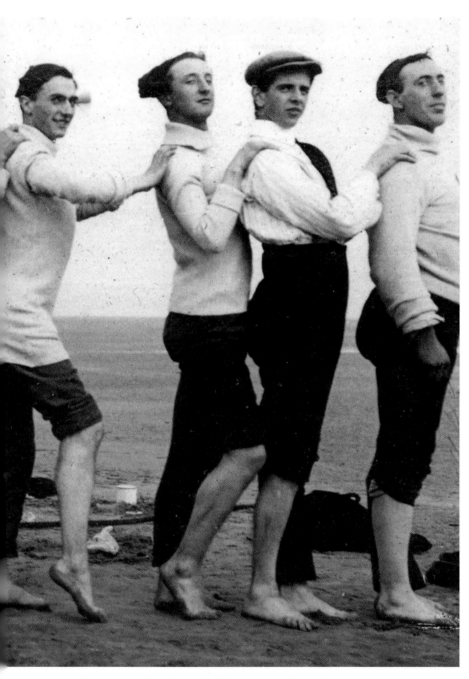

have grit enough we'll make you tough, and you will have in six months such a real good time, such muscles, such hands, and such a constitution that you will bless the day you joined the NBWBC'. (Ref. D6747/1)

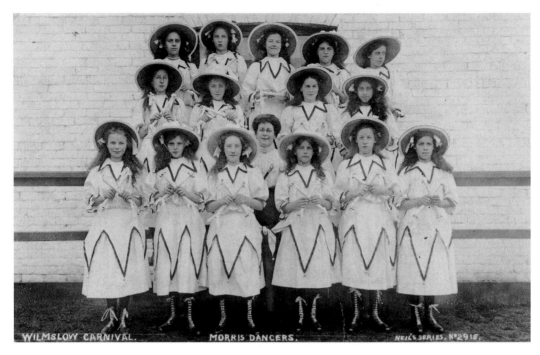

The day the 'dust bin lids went missing… a troupe of 'morris dancers' at Wilmslow Carnival in the early 1900s.

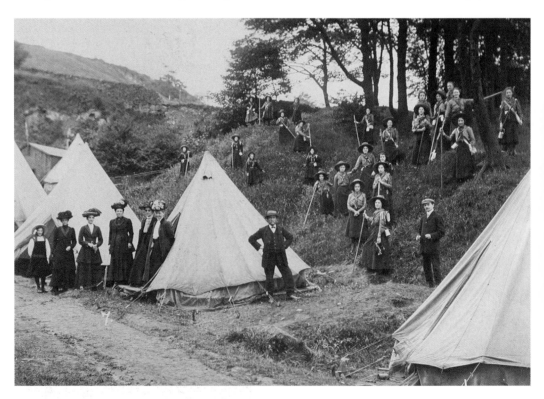

No lightweight camping gear here – 'Visitors' Day' at the Bollington Girl Guides' camp in 1910.

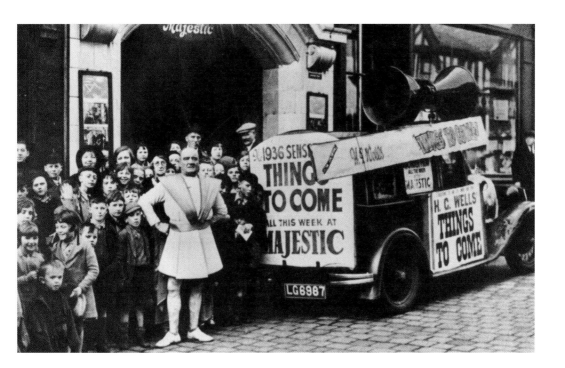

Above: A futuristic figure promotes H.G. Wells's popular utopian vision, *Things to Come*, at the Majestic Cinema, Macclesfield in 1936. Like many of the county's cinemas, it has now closed its doors.

Right: New Brighton Tower, which opened in 1900, stood a massive 567ft (172.8 metres) above ground level, substantially taller than the tower at Blackpool. The 35-acre complex included a shopping arcade, theatre, ballroom (complete with the Tower Orchestra), lake, and menagerie. Neglected during the First World War, the tower was declared unsafe and had to be demolished – a difficult job which was completed in 1921.

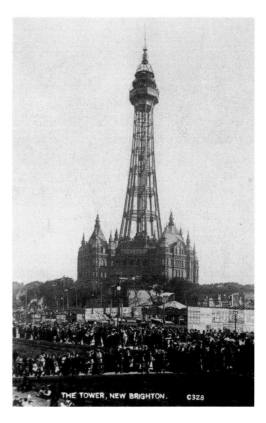

THE TOWER, NEW BRIGHTON. C328

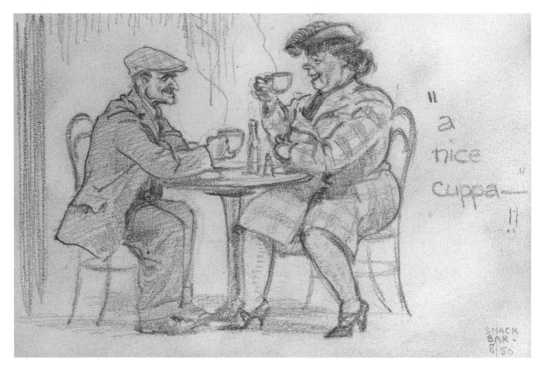

Café society in 1950s Northwich. This snack bar scene was drawn by local artist W.H. Hutchings.

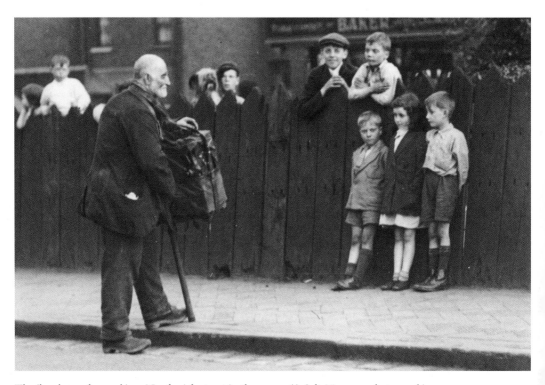

The 'hurdy-gurdy man' in a Northwich street in the 1930s. (A Salt Museum photograph)

six

Transport

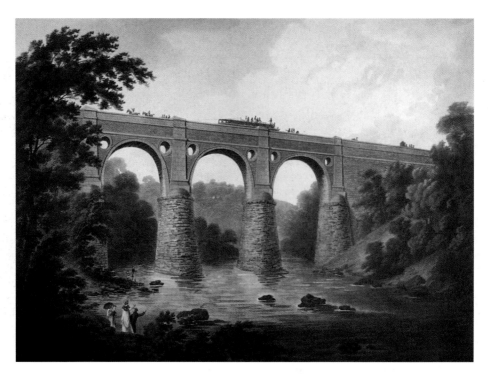

An 1803 print of Marple Aqueduct, built by the Derbyshire canal engineer Benjamin Oultram to carry the Peak Forest Canal over the river Goyt. The aqueduct took six years to build and opened in 1800.

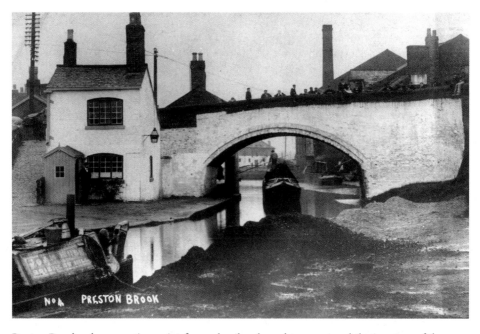

Preston Brook, a busy meeting point for road, rail and canal transport and the junction of the Trent & Mersey and Bridgewater canals.

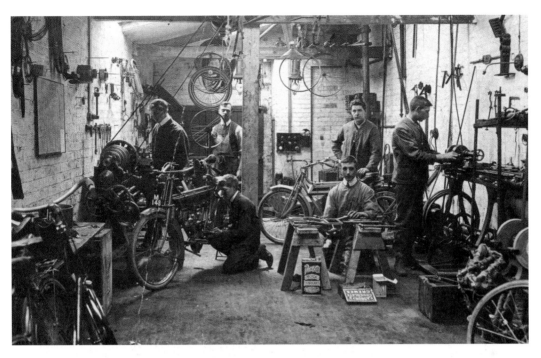

The Winsford premises of cycle manufacturer John Stubbs in about 1914.

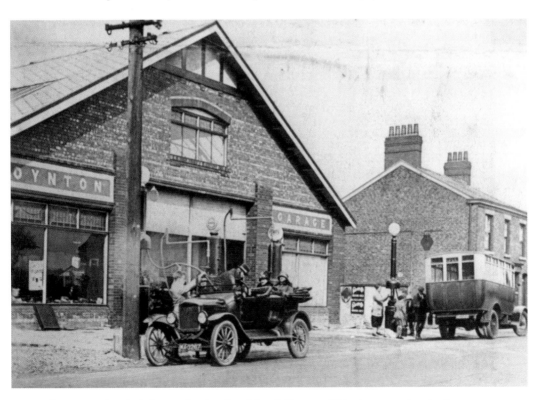

Filling up at Shrigley's Garage, London Road South, Poynton. This view was taken in about 1924.

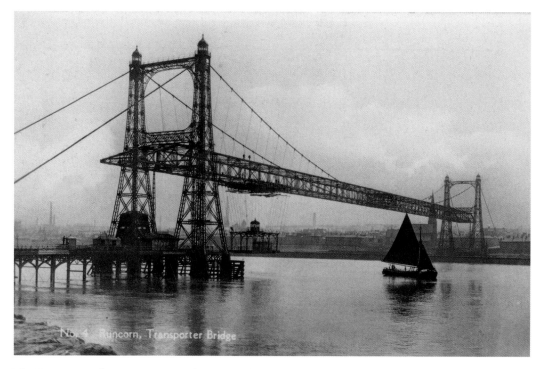

The Runcorn-Widnes Transporter Bridge was the largest bridge of its type ever built. It opened in May 1905 and was twice visited by King George V, in 1905 and 1925. The final crossing was on 22 July 1961, after which the bridge was demolished.

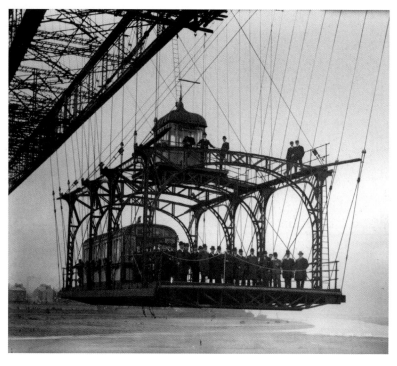

The transporter car in 1905. This car was replaced with a much lighter example when the bridge was overhauled prior to reopening in 1913. On average, the crossing took about three minutes.

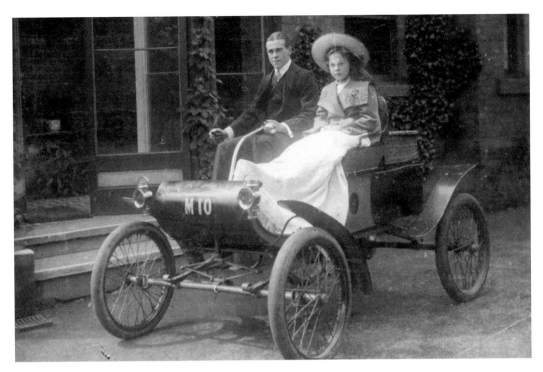

Edye Bellamy of Crumpsall, Manchester, well wrapped up in her father's 4½ horsepower, 'curved dash' Oldsmobile, *c.*1910. According to records, from 14 December 1903, the car's first registered owner was Miss Dorothy Briggs of Dean Row, Wilmslow.

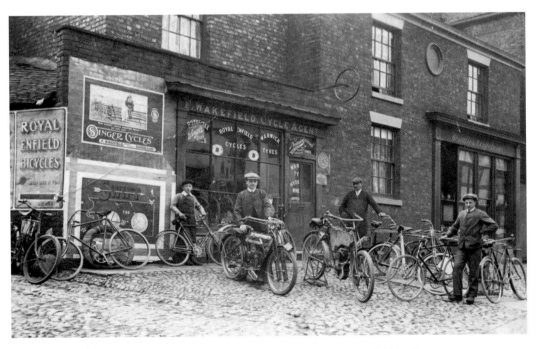

Cycles and motorcycles outside the shop of Sandbach dealer Fred Wakefield in about 1910.

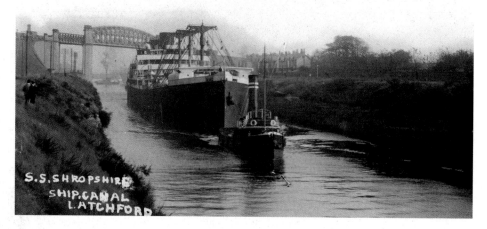

SS *Shropshire* on tow through the Manchester Ship Canal. Built by Clyde shipbuilders John Brown to take emigrants to Australia, SS *Shropshire* was launched in 1911. She was successfully used as a troopship in 1917 but was less fortunate in the Second World War. Renamed *Rotorua*, it was torpedoed and sunk off St Kilda in 1940.

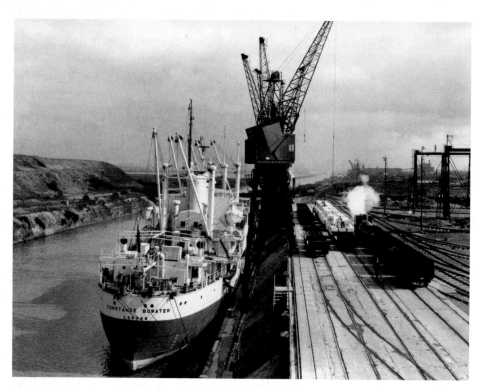

The *Constance Bowater* docked in 1958 in the Manchester Ship Canal at Ellesmere Port, where Bowaters was a major producer of newsprint. One of several company vessels that carried the family name and traded between the UK, North America and Scandinavia, the *Constance Bowater* was sold to a Greek concern in 1972 and finally scrapped in 1985.

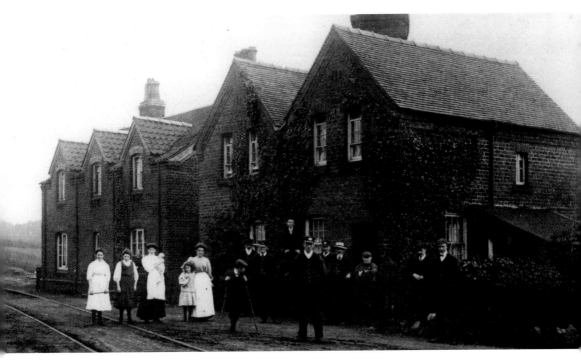

Cottages for railway employees near Delamere station, pictured in about the 1920s.

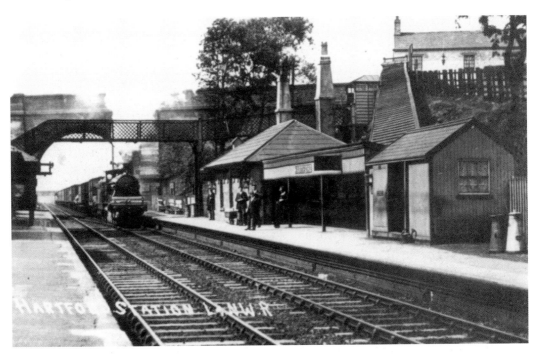

Hartford station in the late nineteenth century. Missing from the picture today, apart from the train, would be the buildings on the right, the chimneys, the milk churns, the pedestrian crossing (now concrete rather than iron) and the covered way up to the Chester road.

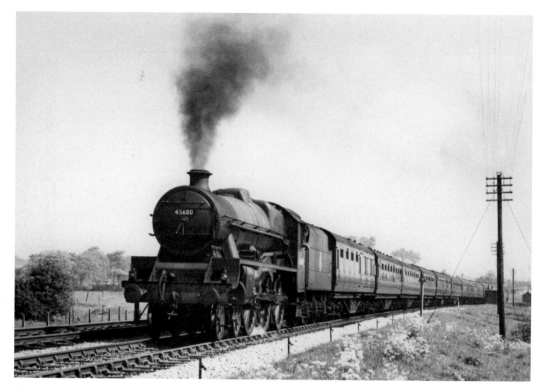

For railway enthusiasts, a fine study of steam by Cheshire photographer Martin Welch. The Jubilee class 4-6-0 'Camperdown' Manchester-Euston express is captured on Macclesfield's 1-in-100 Moss Bank.

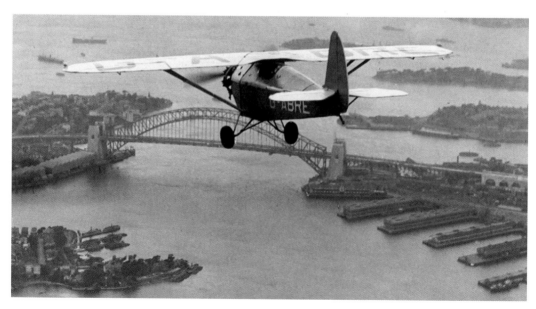

The diminutive Comper 'Swift' flown by Charles Butler arriving in Sydney after a record-breaking flight from England in 1931. Both plane and engine were designed at Hooton Park on the Wirral. Pilot comfort was not a priority – the pilot's baggage was limited to 1½lbs (0.68 kilos)!

seven

Events

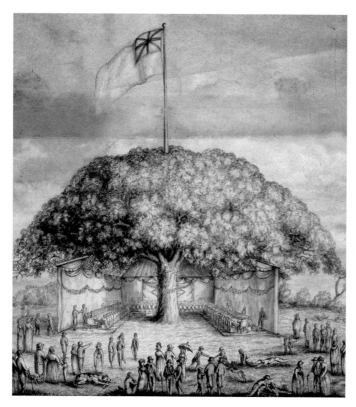

A special dinner for 124 distinguished guests was held under the enormous Winwick Broad Oak (said to cover an area 100 yards in circumference) on 26 August 1811. It was held in honour of Captain Phipps Hornby (1785-1867), son of the rector of Winwick and commander of the naval ship *Volage* at the Battle of Lissa (now Vis, off Dalmatia). Captain Hornby's successful naval career culminated in his appointment as Admiral Hornby in 1858. (Ref. D 7147/4)

Parish registers of baptisms, marriages and burials can date from as early as 1538. Nantwich's oldest volume starts the following year and includes contemporary notes on local and national events, such as the Great Fire of Nantwich (1583), the Spanish Armada (1588) – shown here – and the Earl of Essex's raid on Cadiz (1596). (Ref. P 120/4525/1)

The baptism of Emma Lyon – later to become Lady Hamilton – at Neston church on 12 May 1764. The daughter of an illiterate blacksmith, at seventeen she left Cheshire for London where her vivacity and beauty – there are fifteen paintings of her in the National Portrait Gallery alone – soon brought her to the notice of London society. She was in Naples with her husband, fifty-four-year-old Sir William Hamilton in 1798, when she met Horatio Nelson. The rest, as they say, is history. Inset is one of many studies of her by Romney. (Ref. P 149/1/4)

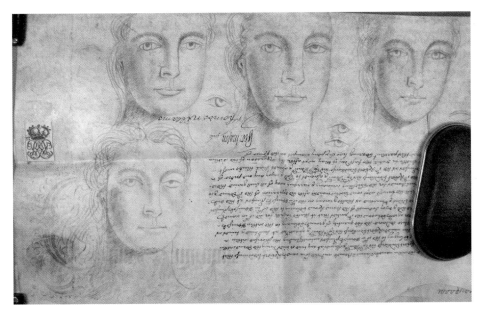

These portraits were found on a title deed of 1702. Perhaps they are intended to depict Anne, the new Queen, then aged thirty-six, or possibly just a woman known to the artist. The drawings appear to be contemporary with the deed, but why they should have been drawn on a current legal document remains a mystery. (Ref. DDW 3765/54/1)

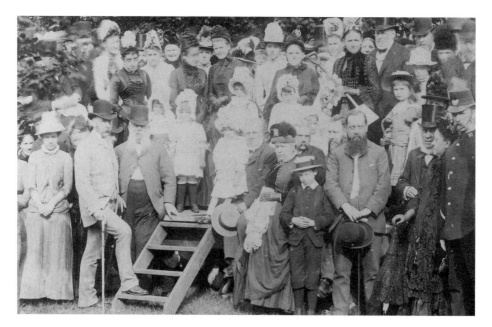

In honour of Queen Victoria's Jubilee, an oak sapling was planted by the mayoress at Macclesfield's Victoria Park on 22 June 1887. Park officials were embarrassed when it was found that the key to the box containing the special silver spade had been left behind. Attempts were made to prise the box open but they failed and the plate glass cover had to be smashed open for the ceremony to proceed. One of the officials can be seen lying hidden under the steps – perhaps the one who forgot the key!

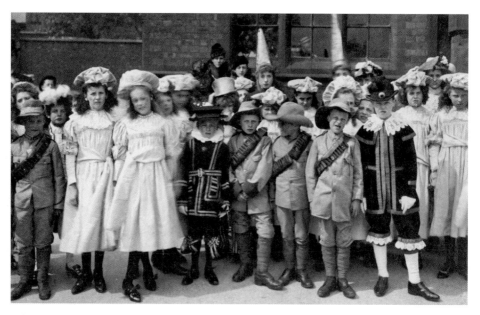

Children gather for Knutsford May Day celebrations in 1902, some of the boys clearly equipped for war in South Africa. 'Officially' since 1864, but undoubtedly for much longer than this, May Day has been a time of special celebration in Knutsford, none more so than when the Prince and Princess of Wales made it a royal event in 1887.

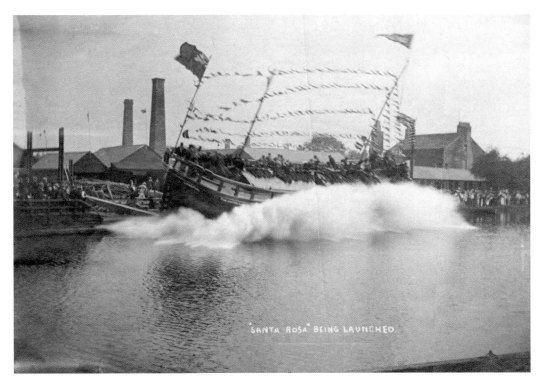

The launch of the *Santa Rosa* at Sankey Bridges, near Warrington, in 1906.

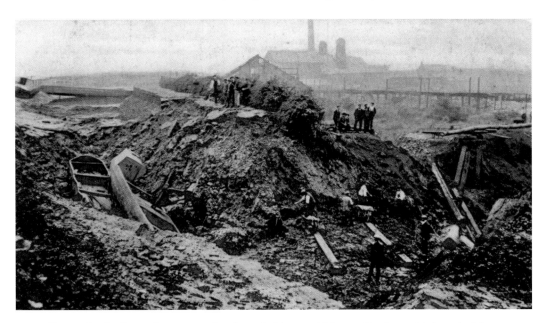

Thousands of gallons of water were lost from the Trent and Mersey Canal near Marbury in July 1907 when subsidence caused the canal to burst its banks. Some boats were capsized; others were carried away in the torrent of water. Spectators flocked in to see the damage, hampering the work of the repair gangs. The canal reopened on 8 August 1907.

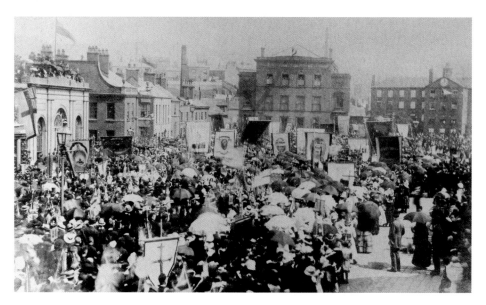

Uncle. I will give a piece of advice, that is when when you go into company again, after you have talked half an hour without intermission, I recommend it to you to stop a while, and see if any other of the company has any thing to say.

I conclude with subscribing myself your very affectionate friend M.D. Riley.

The Davies-Colley collection contains much original nineteenth-century correspondence. This example, written by a precocious nephew, M.D. Riley, whose handwriting suggests a child of pre- or early teenage years, reveals an awareness of etiquette if not of tact. (Ref. DCO 4/137)

Sunday schools gather on Park Green, Macclesfield for Queen Victoria's Jubilee celebrations in June 1887.

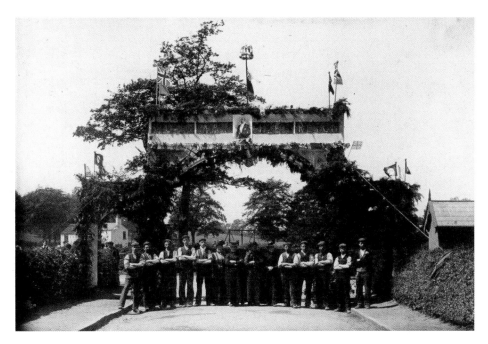

Arches of one kind or another were a popular means of public celebration in the early 1900s. Here, an arch has been set up in Albert Road, Bollington, to celebrate the Coronation of Edward VII, which took place in August 1902.

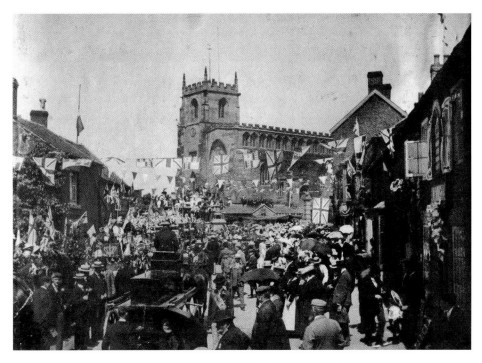

As at Bollington, all the stops are pulled out in Shropshire Street, Audlem, for the 1902 Coronation.

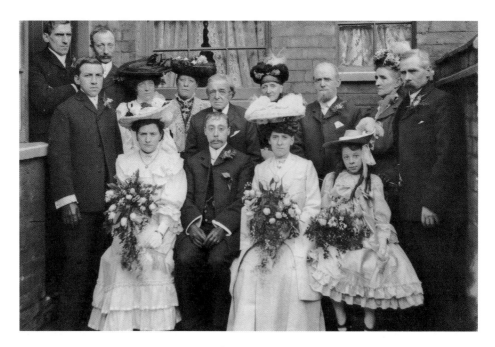

Smile, please. Please... An Edwardian wedding party in Winnington, recorded by local photographer Llewelyn Evans. (A Salt Museum photograph)

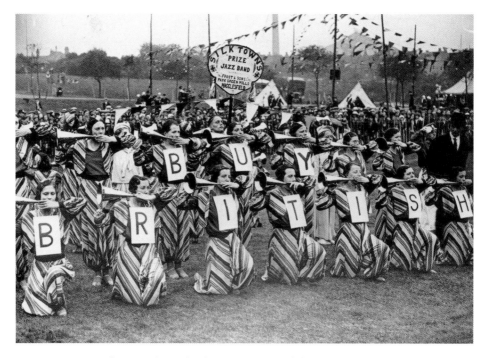

A patriotic message from Frost's jazz band in 1930s Macclesfield.

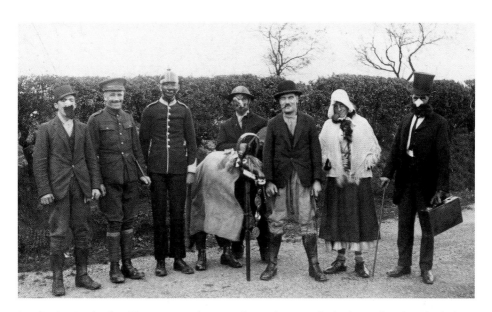

'Souling' or 'soul-caking' became popular around Antrobus, Comberbach, Rudheath and Whitley. Performers and children toured their village, sang traditional songs and received cash or cakes. 'The mumming' or 'soul-caking play' was performed on All Souls' Day (2 November). In the play, a fight led to a death but a doctor restored the victim to life. The cast of motley characters – usually in modern dress – included the Black Prince, the King or Saint George, an old woman, the quack doctor and Beelzebub. (Ref. D5154)

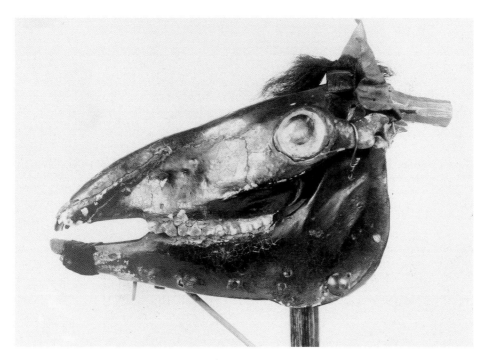

Soulers in Cheshire were often accompanied by a hobby horse – a man in a white sheet wearing a horse's head. This usually had jaws that opened and shut. (Ref. D5154)

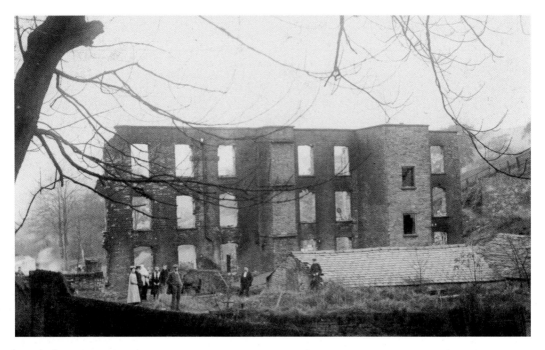

Rainow Mill, gutted by a fire on 11 November 1908. With no fire service in Bollington, the fire had taken a firm hold by the time the volunteer fire brigade arrived from Macclesfield. The cotton mill is believed to have stood on the site of both an earlier paper mill and a medieval corn mill.

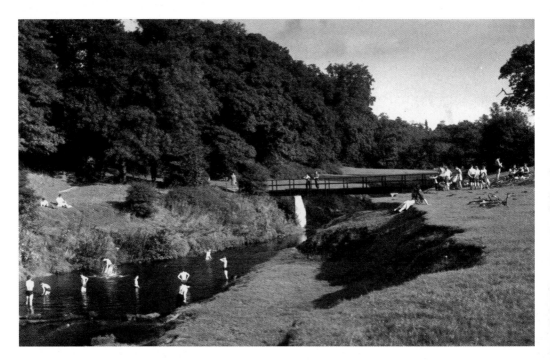

Bathing in the Bollin. It must have been a warm summer – Digley Stair Bridge on the river Bollin, photographed by T. Baddeley on 25 September 1949.

eight

Health and Welfare

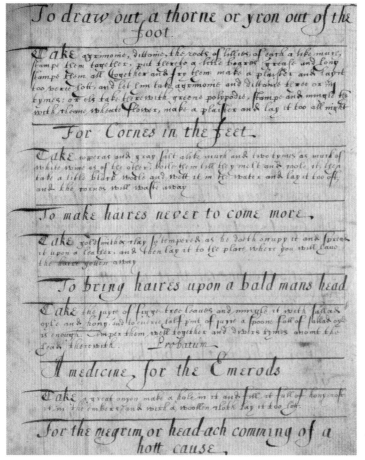

A page from a fifteenth-century herbal by Odo of Meung (or Macer), which contains many recipes (or receipts) for the cure of diverse conditions – for example, a plaster made from rue and 'lorer' (laurel?) leaves was a cure for 'swollen ballokes'; savory with wine 'will make thee to pisse' or alleviate menstrual problems ('women's flowers'). Lechery could be restrained with thyme, wine, honey and pepper. (Ref. D 4398)

A cure for baldness and 'a medicine for the emerods' – taken from an early recipe book inscribed, 'the ever honoured and right worshipfull Mrs Elizabeth Stanley of Alderley… 16 July 1653'. (Ref. DDX 361)

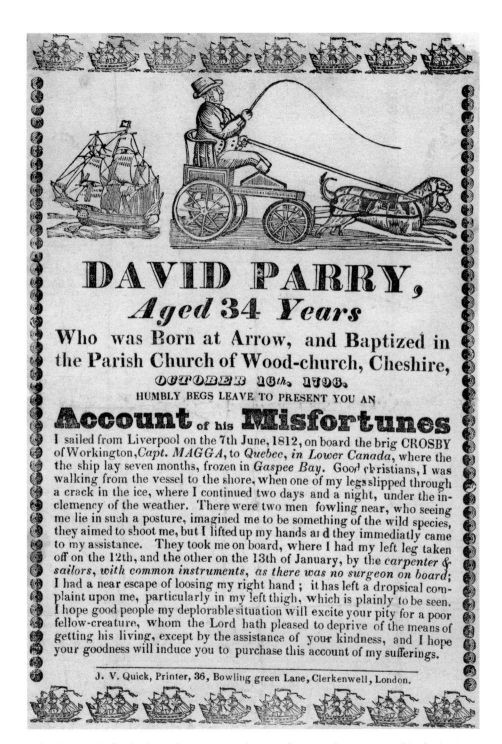

DAVID PARRY,
Aged 34 Years

Who was Born at Arrow, and Baptized in the Parish Church of Wood-church, Cheshire, OCTOBER 16th, 1796.

HUMBLY BEGS LEAVE TO PRESENT YOU AN

Account of his Misfortunes

I sailed from Liverpool on the 7th June, 1812, on board the brig CROSBY of Workington, *Capt. MAGGA,* to *Quebec, in Lower Canada,* where the the ship lay seven months, frozen in *Gaspee Bay.* Good christians, I was walking from the vessel to the shore, when one of my legs slipped through a crack in the ice, where I continued two days and a night, under the inclemency of the weather. There were two men fowling near, who seeing me lie in such a posture, imagined me to be something of the wild species, they aimed to shoot me, but I lifted up my hands and they immediatly came to my assistance. They took me on board, where I had my left leg taken off on the 12th, and the other on the 13th of January, by the *carpenter & sailors, with common instruments, as there was no surgeon on board*; I had a near escape of loosing my right hand ; it has left a dropsical complaint upon me, particularly in my left thigh, which is plainly to be seen. I hope good people my deplorable situation will excite your pity for a poor fellow-creature, whom the Lord hath pleased to deprive of the means of getting his living, except by the assistance of your kindness, and I hope your goodness will induce you to purchase this account of my sufferings.

J. V. Quick, Printer, 36, Bowling green Lane, Clerkenwell, London.

A fund-raising leaflet for the unfortunate David Parry of Arrow, who was trapped in the ice in Canada in January 1813 and had to endure both legs being removed by the ship's carpenter 'with common instruments'. Long before sophisticated prosthetics, David Parry may well have travelled in a cart similar to the one shown in the woodcut at the top of the page.

Days of Admission 1750	No. of Patients	Patients Names	I.P.O.P.	Recommenders	Age	Parish
Nov: 7	1369	Catharine Colley	115	Dodliston Parish	26	Dodliston
7	1370	John Hall	116	Mr Vaughan	51	St Mary
7	1371	Eliz: Gallion	117	Mr Hesketh	21	St John
7	1372	Martha Williams	174	Mr Thomas	80	St Mary
7	1373	Mary Roberts	175	Dr Tylston	29	Northop
7	1374	Mary Cratchly	176	Jr: Barnston Esq:	60	St Oswald
7	1375	Eliz: Bellett, Ballard	177	Mr Warrington	70	St Oswald
7	1376	Thom: Pritchard	178	Dr Tylston	60	St Bridget
7	1377	Jane Jones	179	Mrs Roberts		Trinity
7	1378	Thom: Harington	100	Mr Golborn	44	Hawarden
7	1379	Mary Jordan	101	Mr Thomas	5	St Mary
7	1380	Jane Stubs	102	Dr Cowper	63	St John
7	1381	Judith Williams	103	Mr Goodwin	23	St Mary
7	1382	Sarah Atkinson	118	Dr Fernyhough	20	St John
8	1384	John Walker	119	Accidental	66	St Mary
14	1385	Mary Brome	104	Dr Fernyhough	27	St John
14	1386	Mary Shearer	105	Mr Jnº Colgreave	27	St Mary
14	1387	Ann Powell	106	Mrs Davies	33	Backford
14	1388	Thom: Powell	107	Mr Wrench	44	St Mary
21	1389	Mary Roberts	120	Mr Whishaw	29	Northop
21	1390	Owen Salisbury	121	Mr Thomas	19	Caful
21	1391	Mary Wright	108	Mr Richardson	29	St John

Chester Infirmary was built in 1758 as a charitable institution. These pages from the hospital register for that year give patients' names, parish, date of admission, surgeon, illness and

Physicians and Surgeons.	How long, ill before Admission.	Distempers.	When discharg'd	How discharg'd
Mr Weaver.	1 Year.	Epilepsy.	March 27, '59.	Relieved.
Mr Vaughan.	1 Year	Sore Leg.	Jan: 2, '59.	Cured.
Ditto.	6. Months.	Venereal.	Feb: 27. '59.	Cured.
Ditto.	Sev.l Years.	Sore Leg.	Jan: 9, '59.	Cured.
Mr Weaver.	2. Months.	Dropsy.	Nov: 21. 50.	Made I. P.
Ditto.	Many Years.	Hysterical.		
Ditto.	1 Year.	Pain in her Breast.	Feb: 6, '59.	Cured.
Ditto.	5 Years.	Cough.	Feb: 13, '50.	Cured.
Mr Vaughan.		Sore Hand.	Jan: 9, '59.	Cured.
Mr Weaver.	10. Months.	Dropsy.	Jan: 15, '50.	Cured.
Mr Vaughan.	8 Weeks.	Sore Eye.	Feb: 26, '50.	Cured.
Mr Weaver Vaughan	Sev.l Months.	Swel: in her Leg & Hands.	Dec: 26, 30.	Relieved
Ditto.	2 Months.	Hurt with a Fall.	Feb: 27. '59.	Cured.
Ditto.	1 Week.	Sore Leg.	Nov: 6, 59	Feb: 20. O.P Cured
Ditto.	——	Broken Thigh.	Feb: 20. '59.	Cured.
Mr Denton.	1½ Year.	Melancholy.	April 12, '59.	cured
Ditto.	Sev.l Years.	Consumption.	July 3, '59.	Relieved
Ditto.	Sev.l Years.	Asthma.	July 17, 39.	Cured.
Ditto.	2. Months.	Rupture.	Nov: 20, '50.	Cured.
Mr Hayes	5 Weeks.	Dropsy.	Dec: 26. 20.	Cured.
Mr Rachetta	8. Months.	Sore Leg.	Jan: 16 59.	O.P. Cured.
Ditto.	6 Weeks.	Lame Arm.	Feb: 27. 59.	Cured.

details of when and how they were discharged. The success rate appears to have been high.
(Ref. ZHI 51)

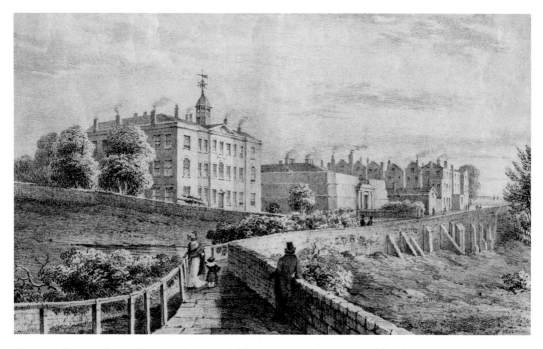

Chester Infirmary, viewed from the city walls. Additions were made to the building into the twentieth century, at the end of which all was demolished except the original structure, which was converted into luxury flats.

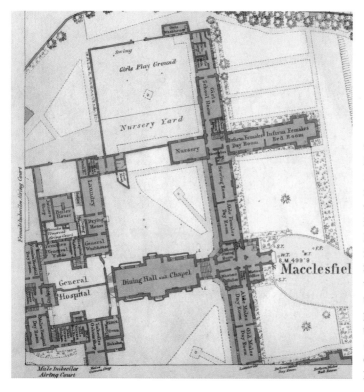

Ordnance Survey plan of Macclesfield Workhouse, 1875. The segregation of male and female, old and young, and fit and infirm is evident from the map. Relief was given in return for labour – the 'Oakum Shop' at bottom left was where cut lengths of old tarred rope would be picked and pulled apart, a tedious and unpopular task. (Reproduced from 1871 Ordnance Survey sheet, XXXVI.8.17)

REPUTED FATHER.	MOTHER.	Male or Female.	Date of Order.	Order ₱ week		REMARKS.	No. Weeks	Quarter. Due 25th June.	
				Order upon Father	Order upon Mother			Date.	Recd.

Illegitimate Children for which m

J. Higginson Runaway	Mary Booth	Female		at 1/-	¼ Week				
Carton Robert	Eunice Warts	Female		at 1/-	Culcheth Workhouse				
No Order made	Eunice Wart	Male		at	Do Do				
Transported	Betty Hinton			at 2/-	¼ Week				
Gone to America	Mary Taylor	Female		at 1/3	¼ Week		—		
Dead	Betty Taylor	Male		at 1/3	¼ Week		—		

Parish overseers made provision for unmarried mothers and their children but trying to collect maintenance from the father was no easier than it is today. The left-hand column in this 1831 Lymm register of bastards reveals how difficult this process could be, with fathers listed as 'runaway', 'no order made', 'transported', 'gone to America' and 'dead'. (Ref. P 119/27/1)

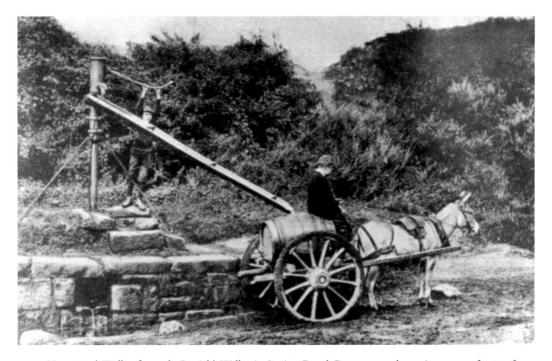

Hampston's Well – formerly Patrick's Well – in Station Road, Burton, was the main source of water for the village before piped water was introduced in the late nineteenth century.

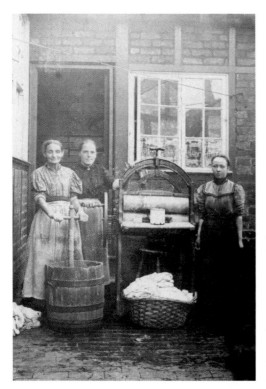

Left: Essential tools before the advent of the washing machine – the dolly tub, dolly peg and mangle – seen here in the yard of a late nineteenth-century wash house in Northwich.

Below: Wilmslow's horse-drawn fire engine, seen here at Fulshaw Hall in the late 1890s. Delays were inevitably introduced by having to gather up and harness the horses and the fire brigade must have been greatly relieved when the motorised fire engine was introduced in 1924.

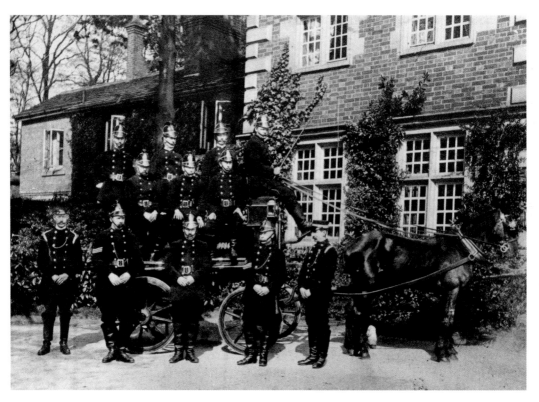

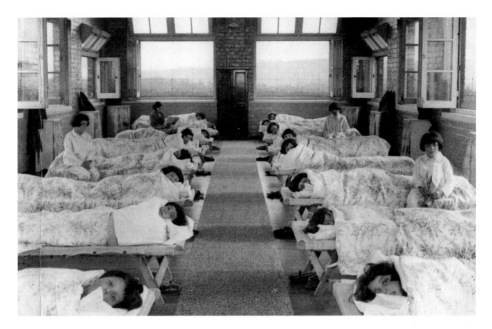

Large open windows feature in the dormitory of the Jewish Fresh Air School in Delamere. The school catered for sickly children – aged between eight and twelve years – from Manchester and Salford, combining a regime of fresh air, healthy diet, traditional teaching and outdoor activities such as gardening, swimming in Hatchmere and rambles through Delamere Forest.

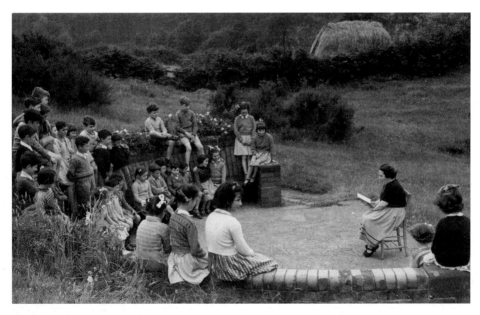

Storytime on the 'Sunny Seat' – Helen Landau, head of the Jewish Fresh Air School from its opening in 1921, reads to the children. She was an inspirational teacher; a reception held to mark her retirement in 1959 was attended by hundreds of her former pupils. She summed up her time at the school by saying, 'my lot has been cast in a very happy place and I have been fortunate to share in work conducive to the welfare and rehabilitation of children. What more can one expect of life?'

The breakfasts revealed also the fact that caste is not confined to India nor to what are called the upper classes in England. Obviously, the best china could not be used at the breakfasts. After one or two mornings had passed, one of the girls handed to one of the helpers a letter, saying "Please, my mother has sent this". The letter read:- To Miss John – Please do not give our Maria her breakfast in a mug again, if you do, I shall not let her come. Maria's grandfather was a Lancashire militiaman, and I have a neighbour who says her half cousin had two terms at a private school. So no more at present only don't

(12)

The decision of the Wesley Guild of Hale (Altrincham) to offer free breakfasts of 'bread and butter, or syrup, or dripping' for poor children early in 1914 produced no shortage of takers – and a bizarre exchange between the guild and one child's mother, appropriately named Sarah Uppish, who requested that her daughter be given tea in a china cup rather than a mug, as her 'grandfather was a Lancashire militiaman and I have a neighbour who says her half-cousin had two terms at a private school'. The committee's reply was somewhat tongue-in-cheek; they 'felt privileged to serve with free breakfasts one of your children, with such a distinguished ancestry and associations', but they were not able to 'provide china and other breakfast requirements suitable for such a case… you may find something suitable at one of the Altrincham old china shops, which keep things as ancient as Maria's illustrious grandfather'. (Maria came to the next breakfast). (Ref. SF HALE/01)

nine

Crime and
Punishment

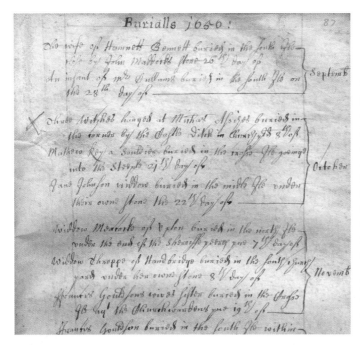

This register for Chester St Mary's records three witches, 'buried in the corner by the castle ditch in the churchyard'. Ellen Beech and Anne Osboston of Rainow and Anne Thornton of Eaton, a widow, were condemned for causing six deaths (one of their victims was an infant) and were executed at Boughton on 8 October 1656. The last person to be hanged for witchcraft in Cheshire was Mary Baguley of Wildboarclough in 1675. (Ref. P 20/1/1)

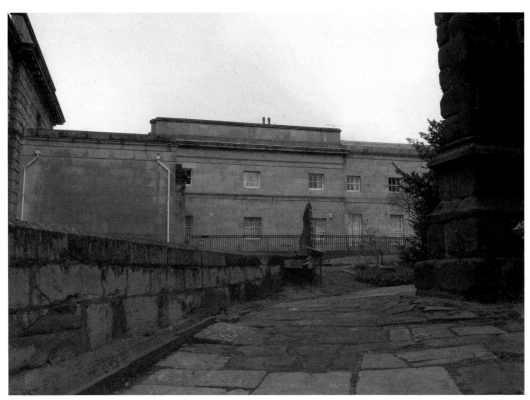

A recent photograph of the area behind St Mary's church, with the boundary ditch to the left, close to where the witches would have been buried.

Madam / Flixton hall in Suffolk Sep.r 19.th
 1757.

I am favour'd with your letter of
the 10.th Sep.r and should think myself very happy if
it was in my power to give you any Assistance
but it is the happyness of our Constitution that
the liberty, property and Security of the person of
every Individual is equaly provided for
without distinction of Rank. — and tho you
may have just reason to complain of the
Insolent behaviour of a low man in your
neighborhood, yet as he does not come within
the discription of such as are liable to be press'd
into the Land Service (having a calling & visible
maintenance) I am afraid you must find
some other Expedient to free your Family from
his impertinence — which seems to arise from
the want of the protection of a Man. A husband
for your self or one of the young Ladies would put
an end to it — or till that happens
let a Serv.t attend the young Ladys in their
walks with a good Cudgel w.ch he ought to
make use of in protecting them from such

In 1757, the widowed Mrs Elcock of Poole Hall, near Nantwich, complained to a Mr Adair, of Flixton Hall, Staffordshire, about the insolent behaviour of a local man towards her and her daughters. In this reply, Mr Adair suggests that she either remarry or hire a servant 'with a good cudgel'. The hall was later rebuilt and occupied at one time by the cricketer A.N. Hornby — a fine player, but also remembered as the first England captain to lose a test match to Australia. (Ref. DMW 6/75)

A 'taste of the cat' on board a Royal Navy sixth rater, the *Levant*, built at Buckler's Hard in Hampshire. This log for 6 May 1777 shows three crewmen being given twelve lashes each for neglect of duty – regarded as a serious offence as it put the ship and crew at risk. More floggings followed, eight men being punished in three days. The captain, John Ward, conducted blockade operations in the western Mediterranean in the 1770s, capturing an American slave-runner off Cape St Vincent. The 'cat' was not officially abolished in the navy until 1879. (Ref. DGR/A/118)

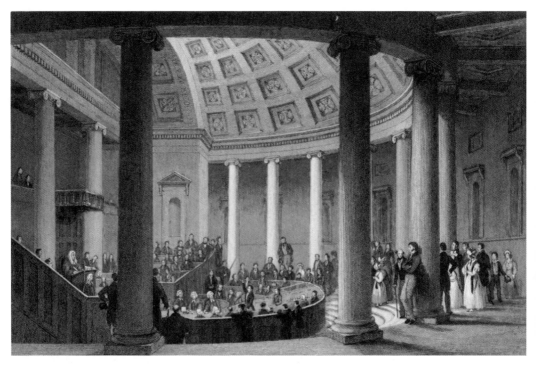

Chester Assizes – the Court of Great Sessions – at the Shire Hall, Chester Castle. The trial of John Lomas and Edith Morrey took place here in August 1812.

A famous murder case captured Cheshire's attention in 1812. Edith Morrey of Hankelow and her young servant and lover, John Lomas, aged twenty-one, were sentenced to death for the killing of Edith's husband, George Morrey. Lomas was hanged in August 1812. Edith's claim to be pregnant was confirmed by a panel of midwives and her execution was stayed until after the baby's birth. She went to the gallows in April 1813 and her body was handed over to a local surgeon for dissection, followed by public display prior to burial. (Ref. QAB 5/8)

JOHN LOMAS.

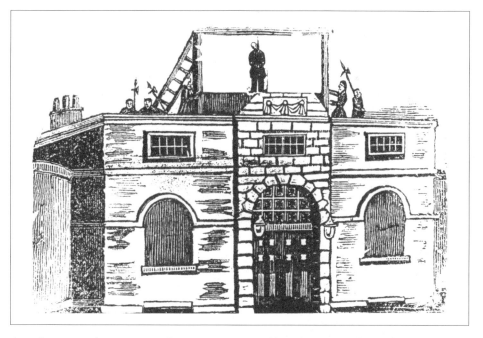

A crude nineteenth-century woodcut representing a public execution at Chester Gaol. Both John Lomas and Edith Morrey were executed here, on a portable gallows erected over the doorway. In a final twist to the story, twenty-one years later, in 1834, her orphaned son, Thomas, whose birth had delayed her execution, was transported to Australia for seven years for theft.

The late Clifford Rathbone, a Macclesfield journalist and local historian, stands in Blakehey Wood, Pott Shrigley, on the spot where two highwaymen, Bates and Walmsley, were apprehended in February 1848. In the fracas, they shot and killed a local man, William Whyatt, who left a wife and seven children. Clifford Rathbone's 'Stroller' articles for the *Macclesfield Express* (of which he became editor) were a popular feature in the paper for many years. (Ref. D6265)

Received on Board the Captivity Portsmouth harbour the Seven undermentioned Prisoners from Chester Castle

Francis Barlow
John Gee
Isaac Hall
William Turner — 93
Alexander Hewitt — 104
Samuel Hadfield — 118
William Lancaster Sampson

Feby 10th 1802

After trial and sentencing at Chester Castle, seven Cheshire men are here recorded as having been transferred to the prison hulk, *The Captivity*, in Portsmouth in 1802. When the American War of Independence (1775-1783) prevented Britain sending its convicts to America, they were either dispatched to Australia or held, often for years, in prison hulks – redundant warships – moored in the Thames and elsewhere. Conditions on board were usually grim. (Ref. QAB 5/3/2)

November 11th, **1819.**

ESCAPED,

At Half-past 7 o'Clock, P. M.

OUT OF THE

Castle of Chester,

THE UNDER-NAMED CONVICT:

JAMES GILLETT,

Under Sentence of Transportation for Life; 18 years of age, 5 feet 2 inches high, stout make, round face, pale complexion, grey eyes, brown hair, steps short and quick; an Upholsterer by Trade, and comes from Troubridge, in Wiltshire.

The above-named Convict had on when he escaped, the County Cloathing, being half red and half green; and as he left the Clogs he wore behind him, it is supposed he will be seen bare-footed.

Whoever will apprehend the above-named Convict, and lodge him in any of his Majesty's Gaols, shall receive a REWARD of

TWENTY POUNDS,

By applying to Mr. J. E. HUDSON, Constable of the said Castle of Chester; and any person giving such information to the said J. E. HUDSON, as shall lead to the apprehension of the above Convict, shall, upon such apprehension, receive from the said J. E. HUDSON, the sum of FIVE GUINEAS, and their names kept secret; and any person or persons who shall, after this notice, harbour or conceal the above-named Convict, will be prosecuted with the utmost rigour of the law.

M. MONK, PRINTER, CHESTER.

An appeal for the capture of an escaped prisoner in 1819.

Dec 18th. An Inquest held on the Body of Ralph Boothby an Infant of five years old, who was caught in the straps of the Machinery of Halgood & Co. & crushed to death. Verdict. Accidental death.

Dec 19th. Rich.d Gee aga.t Fran.s Southern for leav.g his service Order'd to return.

Dec 19th. Assault. Dav.d Chadwick aga.t Will.m Chapman, Bound over, Sure.s Betsey Bradley Will.m Schofield.

Dec 22d. Law.e Tracy, Thos. Rye and John Josephs committed as Vagrants 1 Mon.th

Dec 23rd. Assault. Ann Schofield aga.t John Schofield. Sett.d

Dec 23. Assault. Geo. Eaton and Edw. Johnson aga.t Wm Osborne for break.g a Fiddle. Paid 3. 6. 0.

Dec 23.d An Inquest held on the Body of Will.m Sharpley Stay Maker who died in a Lodging house in Dog Lane under suspicious circumstances. Verdict. Died by the visitation of God.

Dec 24th. Hen.y Green committ.d for vagrancy. 1 Mo.

Dec 24th. Assault. Mar.a Wilde aga.d Sarah Bamford. Settled

Dec 24th. Assault. John Sevile aga.t Jos.h Orme. Settled.

Dec 24th. Jos.h Orme aga.t John Sevile for taking out of his Drawer two awls; each order'd to pay equal share of expences in both cases.

Dec 24th. a Quack Doctor confined for deserting his Family; order'd out of Town.

SCOLDS' BRIDLE FROM STOCKPORT.

Actual size of Mouth piece

Above: Macclesfield magistrate Thomas Allen kept a record between 1823 and 1825 of summary cases heard by him as borough magistrate, recording details of inquests and significant corporate events. Included here are references to an inquest on Ralph Boothby, 'crushed to death by machinery' aged five, a William Sharpley, who died in suspicious circumstances with the verdict of 'died by the visitation of God', and a 'quack doctor' who was 'ordered out of town'. (Ref. D 4655)

Left: The scold's bridle or brank – complete with nasty tongue plate – was used to restrain speech. It was particularly prevalent in Cheshire – one nineteenth-century writer traced sixteen Cheshire examples, some over 200 years old. Last used publicly in the 1830s, examples are known to have survived at Stockport, Macclesfield and Congleton. A woman sentenced to be bridled would have been led through the town on a chain. The movement would have badly damaged her mouth and tongue as well as her self-esteem.

TABLEY
Association
FOR THE
PROSECUTION OF FELONS.

WE, the undersigned, Inhabitants of the Township of Tabley and neighbouring Townships, within the County of Chester, have entered into an Association for the purpose of raising a Fund, to defray the Expenses of Apprehending and Prosecuting to conviction any Offender, who shall be found guilty of a Felony or other Crime against, upon, or to the prejudice of the Persons, Possessions or Property of us, or any of us.----And do hereby offer the following Rewards, to any Person or Persons who shall give Information, that may lead to the Conviction of any such Offender or Offenders, guilty of

	£. s. d.
Burglary, Highway-Robbery, House-Breaking, Horse-Stealing, Arson, Stealing any Cow or other Cattle, Sheep, or Swine, Robbing Barns, or Granaries, Stealing Boards, Timber, or Trees.	5 - 5 - 0
Robbing Gardens or Orchards, BREAKING DOWN STILES, GATES, RAILS, or other FENCES, or Lopping or Cropping Trees or Hedges, Stealing Potatoes, Turnips, Corn in the Field, Hay Grass, or Straw, or Damaging or Destroying Implements in Husbandry, Coursing, Shooting, Fishing, or Poaching on the Lord's Day.	1 - 1 - 0

Any other Felonious Act or Crime, not before specified, such Reward as the Committee for the time being shall think proper to allow.

NETHER TABLEY.
Right Hon. Lord de Tabley
Mr. John Carter
Samuel Weston
John Foster
John Earl

OVER TABLEY.
Mr. Thomas Burgess, Sen.
James Cawley
William Burgess
Thomas Smith
Thomas Burgess, Jun.
Charles Gleave
George Hewitt
Joseph Ashbrooke
Thomas Hickson
Henry Ockleston

BEXTON.
Mr. Ralph Hough
Joseph Starkey
John Hough

PLUMLEY.
Mr. Joseph Williamson
John Hazlehurst
William Coppock
John Newton
William Leicester
William Groves
Thomas Foster
William Dodson
Nathaniel Corbishley
Thomas Blease
John Smith
Baguley Caldwell

NETHER PEOVER.
Rev. J. Holme
Mr. James Ledward
John Allen
William Caldwell
Peter Toft
William Lea

ASTON.
Mr Thomas Prescott
Peter Carter

WINCHAM.
Mr. Peter Woodward

MARSTON.
Mr. John Buckley

KNUTSFORD.
Mr Hugh Wallace

Mr. LEWIS WALLACE,
Secretary and Treasurer.

Tabley, June, 1842.

T. HOWARTH, PRINTER, KNUTSFORD.

From the late eighteenth century, to counter rising levels of crime against private property, voluntary associations of citizens were formed locally. Members contributed to a fund which paid compensation to victims, covering the costs of criminal prosecution and compilation of information on delinquents – even to the extent of establishing local private police forces, 'watches' and 'thief-takers'. Posters were printed to advertise rewards for apprehending suspects. A few associations survive, mostly as dining clubs. The Cheshire Record Office holds records relating to associations at Tabley, Utkinton, Wincham, Hatherlow, Davenham, Dodleston and Somerford with Radnor. (Ref. DLT/D 297/2)

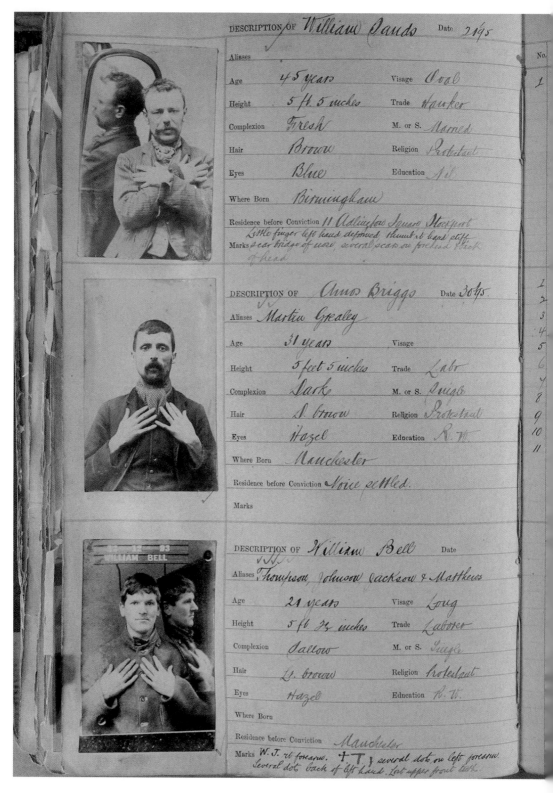

DESCRIPTION OF *William Sands* Date 2195

Aliases		No.	1
Age	45 years	Visage	Oval
Height	5 ft. 5 inches	Trade	Hawker
Complexion	Fresh	M. or S.	Married
Hair	Brown	Religion	Protestant
Eyes	Blue	Education	Ill
Where Born	Birmingham		

Residence before Conviction 11 Adlington Square Stockport

Marks Little finger left hand deformed thumb rt hand stiff scar bridge of nose, several scars on forehead & back of head

DESCRIPTION OF *Amos Briggs* Date 3045.

Aliases	Martin Grealey		
Age	31 years	Visage	
Height	5 feet 5 inches	Trade	Labr
Complexion	Dark	M. or S.	Single
Hair	D. brown	Religion	Protestant
Eyes	Hazel	Education	R. W.
Where Born	Manchester		

Residence before Conviction None settled.

Marks

DESCRIPTION OF *William Bell* Date

Aliases	Thompson, Johnson, Jackson & Matthews		
Age	21 years	Visage	Long
Height	5 ft. 7½ inches	Trade	Laborer
Complexion	Sallow	M. or S.	Single
Hair	L. brown	Religion	Protestant
Eyes	Hazel	Education	R. W.
Where Born			

Residence before Conviction Manchester

Marks W. J. rt forearm. †T & several dots on left forearm. Several dots back of left hand. Lost upper front teeth.

Side column numbers: 1 2 3 4 5 6 7 8 9 10 11

Offence	Where Convicted.	Sentence.	Name.
6 cvts Manchester for drunk &c			
Stealing a pair of trousers	Stockport	21 days	Wm Sand
16 Drunkenness, no visible means &c &c			
Stealing hat	Salford	6 weeks	A. Briggs
Burglary	Manr Assize	12 months	"
do.	Salford Bro Sess	18 months	"
Larceny	" "	12 months	"
Loitering with intent	Stockport	3 months.	"
Larceny at Stockport	Kfm Sess	12 month	"
Shopbreaking & Larceny therein	Bolton Qr. Sess	18 months	"
Stealing a Kettle	Salford Sess	3 months	"
Burglary	Salford Sess	18 Months	"
do	" "	3 Years P.S.	"
Shopbreaking	Stafford Sess	3 Years P.S.	"
1			
Stealing rags	Lancaster P. Court	21 days	Thos. Matthews
Stealing money from till	Leeds	1 c. month	Wm Bell
Frequenting	Manchester P. Court	1 c. month	Wm Johnson
Stealing £2 from a till	do.	3 c. months	do.
do	Birkenhead P Court	3 c. months	Wm Bell
do	Liverpool "	1 c. month	do.
Frequenting	Leverpool "	3 c. months	Wm Jackson
			do.
Attempted till robbery	Manchester "	3 c. month	
Stealing silk handkerchief	Bolton Qr Sess	4 c. months } concurrent	Wm Thompson do
£5 from till	do	do	
Attempting to steal aprons	Knutsford Qr Sess	12 c. month	Wm Bell

The Stockport constabulary compiled at least two volumes of photographs and descriptions of known thieves, covering the years from 1879 to 1928. This may have been common practice, although few such records survive for Cheshire. Details of the physical attributes of offenders are given, together with aliases used. Here we have the entries for William Sands, Amos Briggs and William Bell, including their aliases. (Ref. CJP 20/10/2)

107

The log of John Ayre, surgeon superintendent on an emigrant ship to Australia, describes a court held to consider the conduct of Lucy Wells, a female emigrant. The steward of the ship had been found in the young females' ward. Louisa Jury, seventeen, who slept with Lucy Wells, had 'felt someone creep into the bed' and had asked Lucy to move over. Later she 'heard Lucy Wells ask him if he had got his braces'. Lucy's punishment was decided by thirteen – plainly outraged – married females: her hair was to be cut off, she was to be kept apart from the other young females for the rest of the voyage (confined to the hospital under the care of the matron) and she was to be fed on bread and water at the discretion of the surgeon superintendent. The steward seems to have been less harshly treated. He was 'placed in irons' on the poop for twelve hours. (Ref. DWS 19)

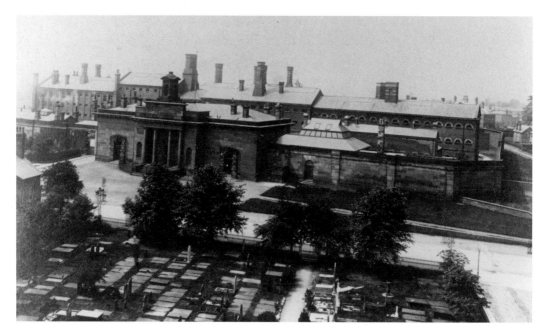

Knutsford Sessions House – still in use as a Crown Court today – with Knutsford Gaol behind. This early 1900s picture was taken from the tower of the parish church. The prison dates from the 1820s. Punishments used included the crank, the treadmill and 'shot drill' – the moving of heavy cannonballs from one pile to another. The prison was used as a training centre for church ministers following the First World War and demolished in the 1930s. It is now the site of a supermarket.

ten

Religion

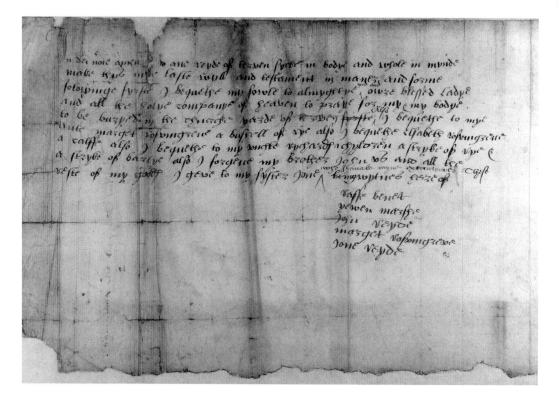

J. BRVEN

Above: The will of Ann Reyde of Tarvin, 1562. Although made in the reign of Protestant Queen Elizabeth, it shows a medieval mindset. Ann bequeaths her soul 'to almightye God and owre blessed ladye and all the holye companye of heaven'. By that date, it was not general practice to acknowledge the Virgin and saints. Ann may have been very old or perhaps an adherent of the old faith. (Ref. WS 1562)

Left: Ann Reyde would have been familiar with Tarvin church (St Andrew's), where, some years after her death, the Puritan John Bruen, of Stapleford Hall, had the 'idolatrous' stained glass removed and replaced with plain glass. Despite his obvious religious prejudices, John Bruen (1560-1625) seems to have been a kind and generous man, well-respected among both the Cheshire gentry and the poor alike.

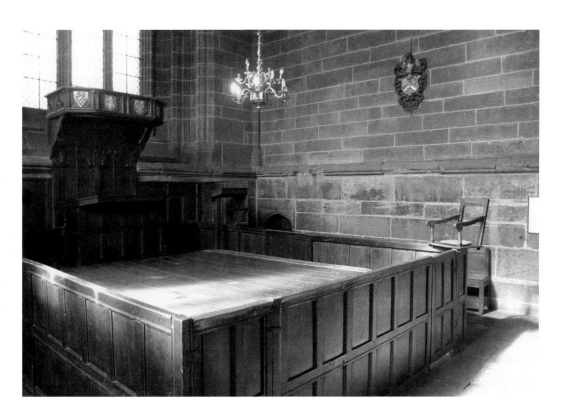

Above: The seventeenth-century Consistory Court in Chester Cathedral, one of very few surviving examples of these courts. Set up to hear cases of immoral behaviour, often resulting in the defendants doing some form of penance in their parish church, the court was presided over by the chancellor of the diocese, whose elaborate, canopied seat can be seen to the left. The raised chair to the right was for the use of the 'Apparitor', a court official whose duties included the delivery of summonses to those required to attend the court.

Right: Punishing an abusive midwife. The Consistory Court of the Bishop of Chester sat to try disputes over tithe and private/ public morality. In this example from 1663, Anne Knutsford of Nantwich was cited for abusing her position to steal, lie, swear and 'make scandalous speeches that, contrary to her profession of a midwife, she hath revealed the secrets of women'. Anne was back in court in 1664 for urging a newly delivered mother to resort to infanticide. (Ref. EDC 5/1663/16)

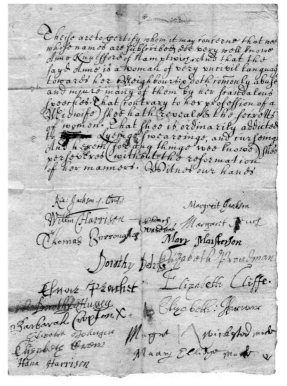

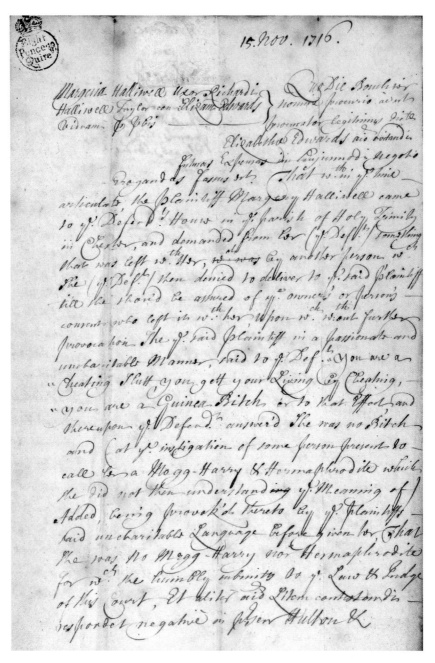

No stranger to confrontation, Chester's Consistory Court heard a case from Holy Trinity parish, Chester, in 1716, when Margery Halliwell accused Elizabeth Edwards of calling her a 'hairy hermaphrodite' and a 'megg harry'. Margery 'did not then understand the meaning of the said words but hath since been informed'. She 'went into a passion' and called Elizabeth 'a cheating slutt' and 'a guinea bitch, or to that effect'. The women clashed when Margery went to collect a stomacher (an embroidered panel worn over the chest or stomach) which Elizabeth had mended. They had to be separated by Lt Boyne, a lodger. (Ref. EDC 5/1716/4)

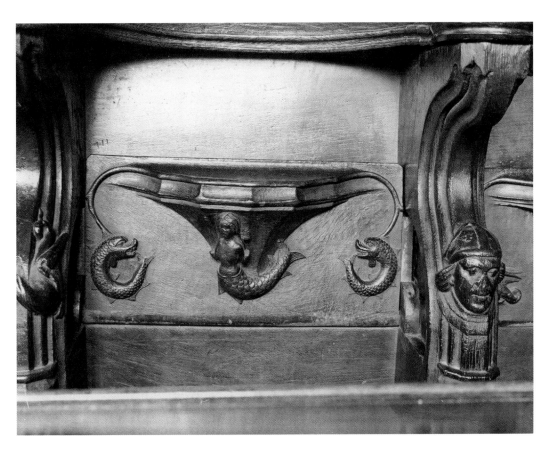

Above: Chester Cathedral has this mermaid carved on a choir stall misericord, dated *c.* 1400. In a similar vein, Cheshire legend has it that a mermaid used to be seen or heard at dawn on Easter Sunday on Rostherne Mere – now a bird sanctuary.

Right: Cheshire is a maritime county (to the west, between the rivers Dee and Mersey) so it is, perhaps, not surprising that images of mermaids are found in some of its artwork. This example, dating from 1761, adds light relief to a survey produced for the Brook House estate, near Alsager. (Ref. P 278/10/1)

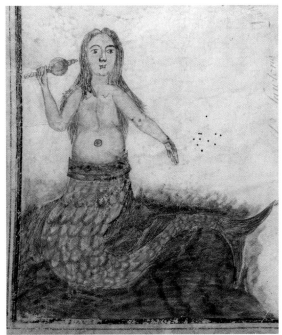

Thomas Woods et Eliz: Goodacre p̄: Lic —
Mensis Jan̄: 4 Georgius Booth et Ann Mitchell p̄: pub — 6
Josephus Howard et Maria Dormon p̄: Lic — 28
Mensis ffeb: 4 Thomas Kelleion et Idiali Watmough p̄: Lic — 6

Marriages Anᵒ Dom: 1741

Mensis Martij Robert Hankison et Maria Haniock p̄: pub: 31
Mensis Apr: Petrus Currey et Sarah Thomas p̄: pub: — 7
Mensis May Johan: Peers et Alicia Peers p̄: pub: — 19
Gulielm: Curtuss et Judith Brierly p̄: pub: 26
Mensis Dec: 6: Gulielm: Mackerall et Maria Haddock p̄: pub: 30

Marriages Anᵒ Dom: 1742

Mensis Septemb: Gulielm: Howard et Margᵗ Pepper p̄: pub — 13

Jacob Adams Rec: ᵗᵉ Johanne Renshall ⎱ Gardianus
 Thomas Burchwood ⎰

This 'fishy' entry was found in the marriage register of Bebington in 1741 – William (Gulielms)
Mackerall weds Mary (Maria) Haddock. (Ref. P 62/1/2)

15ᵗʰ Mary daur of Saml̃ & Ann Firth of Allostock —
29ᵗʰ Emily, Jane, Julia, Moika, a negro girl about 12 years
old from Congo, but now of Lower Tabley —
Dec. 6ᵗʰ John son of George & Elizabeth Roylance of Over Peover
13ᵗʰ Elizabeth daur of Fanny Darlington of Rudheath Lord Mʃ
14ᵗʰ Thoˢ son of Joseph & Martha Tinsey of Little Peover —
27ᵗʰ Joseph son of Samuel & Mary Davis of Lach dennis.
1808:
Jany 3ᵈ James son of Betty Worrall of Allostock Mxʃtᵉ
17ᵗʰ Ann daur of Richard & Margaret Bobham of Lach dᵉ
Robᵗ son of John & Lydia Morton of Blumley —

Cheshire's parish registers bear witness to the presence of several black servants and slaves in
the seventeenth and eighteenth centuries. This extract shows the baptism in November 1807 at
Lower Peover of Emily Jane Julia Moika, a Negro girl about twelve years old originally from
the Congo, but now of Lower Tabley. How long she remained in the area is unknown as there
is no subsequent reference to her in the marriage or burial registers. (Ref. P4/1/4)

Above: Nantwich's parish church, one of the few buildings in the town to escape the Great Fire of 1583. The church is famous for its woodcarvings – quire stalls and misericords – and for its landmark feature, the octagonal tower.

Right: Another octagonal tower, this time belonging to Birtles church, built in 1840 as a private chapel by Thomas Hibbert. It was consecrated as the parish church fifty years later, in 1890. The photograph probably dates from around this period as, by 1920, both church and tower were covered in ivy.

Oct 16 1816

Directions for my Funeral; which I particularly request may be complied with precisely, without the smallest deviation to prevent the infamous plunder of Undertakers whom I have ever held in abomination: To which are added further Directions relative to Family Matters; which I very much wish may be equally attended to & executed.

1st On no account to be screwed up, or removed, till visible change has taken place.

2d That my Coffin be made by a good Carpenter of the very best Oak English & to be well screwed together, not to be covered with black cloth on any account. A common Plate with my Name & age only. To be convey'd in a Hearse with a single pair of Horses only to St Oswalds and deposited in any part of the common burying Ground. The Hearse should be attended with one Mourning Coach & pair of Horses. I particularly direct that no extraordinary Feathers, or the smallest Parade of any sort be used, beyond common decency. That John Pettert & his Son, old John Chamberlins Son if able with David Prince. Fourth, & Thos Twisterton carry me from the Hearse to my grave, and that each of such Bearers have half a guinea for their attendance with Hatbands of Crape & Gloves. That the Revd Mr Fish be requested to bury me, & to be paid five guineas for his trouble. That the Servants may go in the Coach if other Branches of the Family do not & the chaise may follow the coach. I mean everything decent tho not to be settled by the Undertaker: but by my children for my meaning is, to avoid unnecessary & absurd Expence.

3d As my Son (alas! only one) is better provided for than his Sisters. I request that my three Daughters Martha Anne & Frances or whoever of them are alive and unmarried at the Time of my Death (so truly deserving of every Mark of my affection and Remembrance; for their dutiful & amiable Conduct towards their beloved & most excellent Mother & myself) may have as some little aid to their future Establishment (wherever they fix) All my Furniture in or at Newton Hall or Hawthore of every sort. Viz. Plate, Linnen, China, Wine, &c.,

An example of the strange instructions and prejudices sometimes to be found in wills. The 1819 will of George Parker of Newton Hall (Upton, Chester) expresses a desire to avoid 'the infamous plunder of undertakers, whom I have ever held in abomination'. He wished for only 'the smallest parade' and 'to avoid unnecessary and absurd expense'. Parker also insisted that he was 'on no account to be screwed up or removed, till visible change has taken place'. (Ref. WS 1819)

Chester-based 'Church Army' caravan visiting Frodsham in the early 1900s. The Church Army was an evangelical movement founded in 1882 by Revd Wilson Carlile.

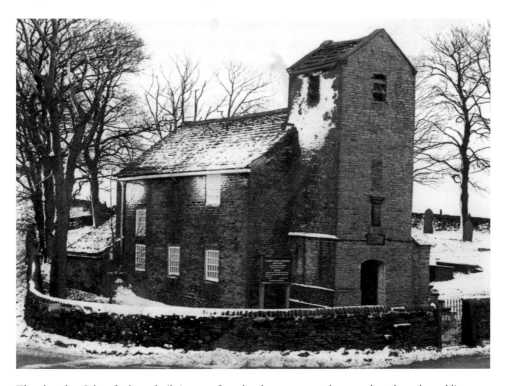

The chapel at Saltersford was built in 1733 from local stone – on what was thought to be public land – at a junction of ancient trackways and saltways. This was not the case and the landowner objected. In the subsequent lawsuit he agreed to sell the land to the trustees for 10 shillings. A curious gravestone at the chapel carries the single word, 'Here'.

Drawing of a cathedral gravedigger by Albin Roberts Burt (1784–1842). The son of a Chancery Lane solicitor, A.R. Burt moved from Bath to Chester in 1812, opening a studio in the cathedral verger's house in Northgate Street. He taught drawing and specialised in painting miniatures that bordered on caricature. He claimed to be able to make a likeness in thirty minutes and charged 10/6 for a quick profile. He is reputed to have travelled around Cheshire by a hobby horse with wheels specially made from light wooden barrel hoops. (Ref. EDD 2/44)

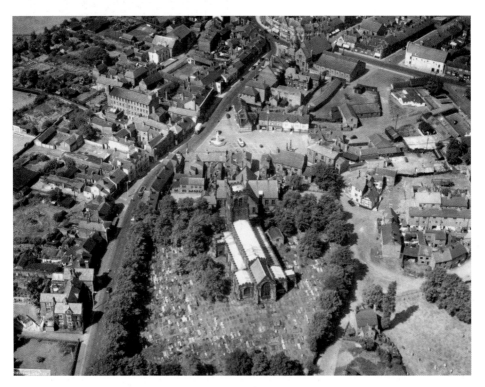

Aerial view of St Mary's church, Sandbach from the 1950s. High Street lies to the left and above the church lies Market Square, with its war memorial and ancient crosses. Parish registers often contain curiosities and Sandbach is no exception: in 1643, for example, we have recorded the burial of 'a certain wandering soldier' and, in 1766, a burial entry for 'a Welch stroller'. The church was largely remodelled by Sir Gilbert Scott in the 1840s, one unusual feature being the arched passage through the tower, introduced because the tower was built over a public right of way.

eleven

Military
Matters

Sir *William Breretons*

LETTER

Concerning

The Surrender of the City

O F

CHESTER

For the Parliament:

Together with the ARTICLES agreed on betwixt both parties, and the Commissioners Names.

SEnt *in a Letter to the Honorable* William Lenthal *Esq; Speaker of the Honorable House of Commons, and appointed to be forthwith printed and published:*

LONDON:

Printed for *Edward Husband,* Printer to the Honorable House of Commons.

February 6. 1 6 4 5.

Parliamentarian pamphlet published shortly after the Royalist forces surrendered Chester to Sir William Brereton in February 1646. The lengthy siege had left its mark – a starving populace and great damage to buildings from regular bombardment. The Cheshire Record Office has a good collection of pamphlets from this period, taking us from a 1641 'Remonstrance against Presbitry' through to coverage of Sir George Booth's uprising in 1659.

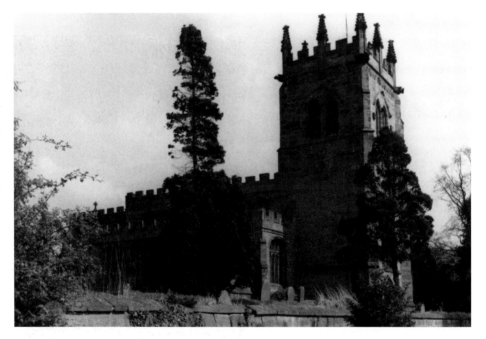

The little village of Barthomley and its lovely church are associated with a grim incident in the Civil War. On 23 December 1643, a Royalist troop of Lord Byron's men, under Major John Connaught, was apparently fired on from the church tower and one man was killed. Twenty local men took refuge in the tower and the cavaliers set fire to furniture and rushes to smoke them out. All were stripped and twelve murdered, Connaught personally killing one man with an axe. Lord Byron later defended his men, saying that mercy was wasted on the enemy. Had Charles I pleaded at his trial, the massacre at Barthomley was to be one of the charges laid against him. Connaught was tried for murder at Chester Assizes in 1654, sentenced to death by John Bradshaw and hanged at Boughton.

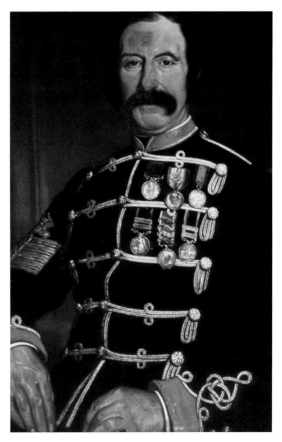

> Since writing this Letter by very good intelli=
> =gence I come to beleeve that y Queen of Spaine
> will onely Serve her selfe. 470. 774. 542. 678.
> instances. 762. 201. 620. 252. th. 256. 59. 470. 585.
> as 17. 52. 681. 761. 678. 220. 470. 201. 620. 81.
> science, & 288. 236. 774. perswad. 991. 201. 620.
> 401. 762. 284. 774. 761. 757. 334. 762. 585. but
> that 241. 26. 955. 712. 36. 87. 145. 288. 375. 166.
> 988.

Above: From the Leicester Warren of Tabley collection – a coded letter dated August 1667, from the Earl of Sandwich in Madrid to Lord Arlington, a government minister, regarding political, military and naval developments. The letters were put partly into code, in groupings of two or three-digit units. Coincidentally, John Wilkins, Bishop of Chester 1668-1672, was an expert in cryptography and the author of the first book in English on that subject, *Mercury, or the Secret and Swift Messenger* (1641). (Ref. DLT 4996/15)

Right: Trumpet-Major Smith (1822-1879) joined the 3rd Light Dragoons at the age of sixteen and fought several engagements on the north-west frontier before serving as a trumpeter at the Charge of the Light Brigade in the Crimea. He later became a trumpet-major in the Cheshire Yeomanry and a well-loved figure in Knutsford, where he was town crier and managed the gentleman's club in Tatton Street. After a spell 'on the spree' at various Knutsford hostelries in November 1879, he died after taking an overdose of laudanum. This portrait hangs in Knutsford Library.

Wilmslow Urban District Council.

RAIDS BY HOSTILE AIRCRAFT

PRECAUTIONS TO BE TAKEN.

By the Order of the Secretary of State of the 8th February, 1916, **HOUSEHOLDERS, SHOPKEEPERS, and** others must **EXTINGUISH ALL EXTERNAL LAMPS, FLARES, AND FIXED LIGHTS OF ALL DESCRIPTIONS,** and all Internal Lights must be **SHADED OR OBSCURED,** so that no more than a dull, subdued light is visible from the outside, and no part of the pavement or roadway, or any building, is distinctly illuminated thereby. Householders should put up **DARK BLINDS** to windows, doorways, and skylights. Fuller particulars will be found in the Order which has been published by means of large posters.

If an attack is imminent, the Police will cause the Buzzer at the Gas Works to give a series of short blasts extending over a period of Four to Five Minutes, and at the same time, and for the same period, the Electric Light and the Gas will be alternately lowered and raised in rapid succession, and then both will be ENTIRELY CUT OFF until the danger is passed.

Gas should be immediately turned off at the meter and the Electric Light at the main switch, and persons are particularly warned to see that all Gas Taps are turned off to avoid escapes when the Gas is turned on again. All Electric Switches should be turned off. Candles can be used if absolutely necessary.

Close all doors and windows, and shutters (if any). Extinguish fires in houses and remove oil lamps, oils, and explosives out of the house if possible. Keep a supply of water in pitchers, buckets, wash tubs, baths, &c., for use in case of fire. Refuge should be promptly taken in the cellar, basement, or lower floor.

Persons must not congregate together or remain in the streets. Congregations of persons should disperse quietly, without panic, to their homes or the nearest place of shelter.

The Fire Brigade and Ambulance Men will hold themselves in readiness at the Fire Station. Qualified Nurses willing to render assistance are requested to send their names and addresses at once to MR. PRIOR, the Deputy Clerk to the Council.

ALL POLICE ORDERS MUST BE IMPLICITLY OBEYED.

PROTECTION AGAINST POISONOUS GASES.—Mix 1 lb. of washing soda in a gallon of water. Dip a towel in the solution, squeeze it out, and apply to the mouth and nostrils.

SAMUEL BOOTH, Chairman of the Council.

February 14th, 1916. WILLIAM COBBETT, Clerk.

Keep this Handbill by you for reference.

E. HULTON & Co., LTD., Printers, Manchester.

First World War poster on air-raid precautions in Wilmslow, showing that the bombing threat was taken seriously – even this far to the north-west.

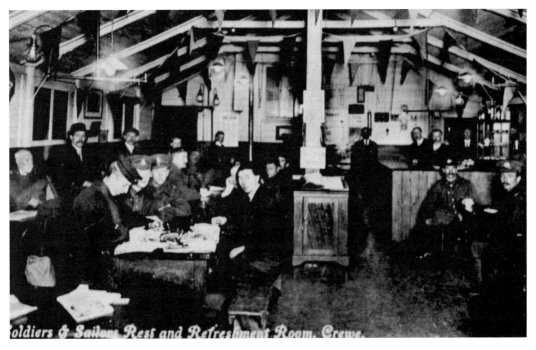

Set up in 1915 near Crewe station, the Soldiers and Sailors Rest provided refreshment for thousands of servicemen who were passing through. To help with the demand, a supplementary canteen service was set up on Crewe station in October 1917.

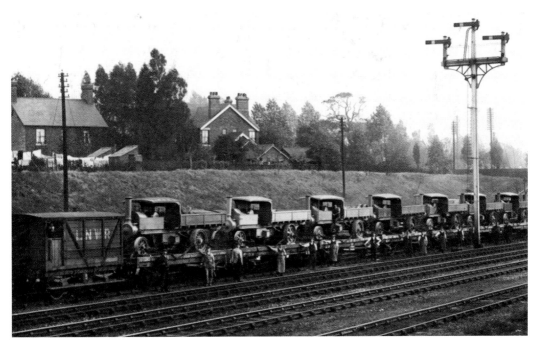

Steam lorries loaded up for shipment to France. This early consignment was from Fodens of Sandbach, sent in 1914.

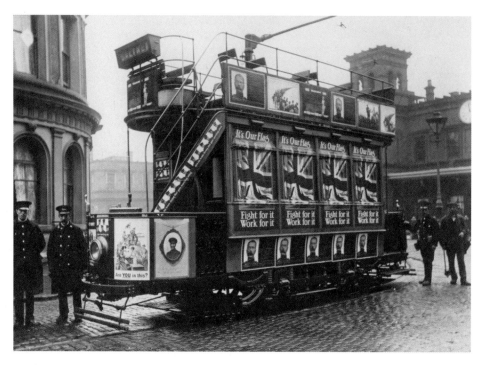

A Chester tram harnessed for recruitment during the First World War. It is parked close to the terminus, near Chester railway station.

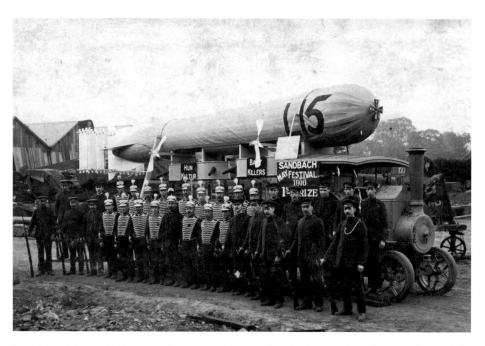

The joiners' shop at Fodens won first prize at the 1916 Sandbach Festival for their mock zeppelin float. The uniforms had originally been bought for the Fodens band to wear for a performance in front of King George V and Queen Mary at Crewe Hall in 1913.

1. Full name and present home address, of Soldier, or Sailor, or if dead or missing his former address.	*Pte* Edward Handsley Townhill 399 High St Winsford Ches
2. Regiments or ship in which he served, with, if possible, Regimental number.	45708 Cheshire Regiment
3. Rank.	Private
4. When he joined. (The year only need be stated).	August 23rd 1916
5. If he served abroad, what countries did he serve in and for how long?	Going to Egypt
6. If killed, wounded, missing, maimed, or died, please give date, and how it occurred.	Drowned at Sea 4th May 1917
7. If he received any honour or decoration please state same.	
8. Please state if married and number of family.	married 3 children
9. If discharged, please give date and cause of discharge.	

Winsford UDC was unusual in keeping a record of what happened to their soldiers and sailors during the First World War. The entry for Pte Edward Townhill, of the Cheshire Regiment, reveals that he drowned en route to Egypt in 1917. He had been with the regiment less than a year. (Ref. LUWn 4656)

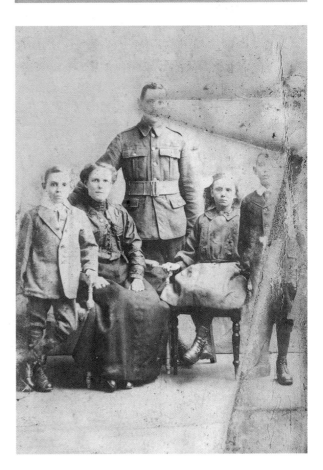

This photograph of Pte Townhill and his family was recovered from his body, found on the shores of the Mediterranean after the sinking of the troopship *Transylvania* on 4 May 1917.

125

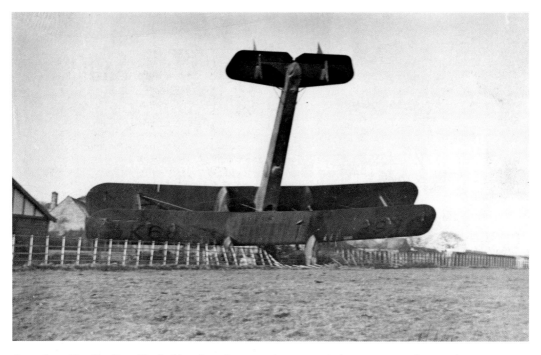

One of two Handley-Page Heyford bombers that came down near Disley in poor weather conditions, en route from RAF Aldergrove (Belfast) to their home base, RAF Finningley, near Doncaster, in December 1936. Seven bombers left Belfast – only one reached Finningley.

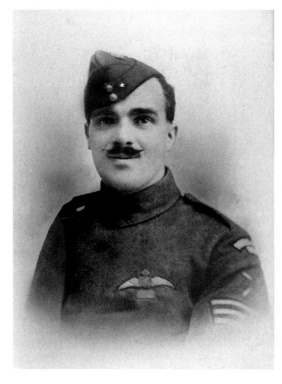

Widnes-born Sergeant Thomas Mottershead was the only non-commissioned officer to win a VC in the air force during the First World War. He worked as a fitter at shipbuilders Cammell Laird before joining the RFC as a mechanic in 1914. Soon drawn to flying, he qualified as a pilot at Upavon and reached France in 1916. In January 1917, with his plane set on fire during a dogfight, he suffered terrible burns but reached safety and saved the life of his observer. He died from his injuries a few days later. The following June, his young widow received his posthumous VC.

PUT YOURSELF
IN OUR SHOES!

In pre-war days we used to try to persuade you **to buy a wireless set** (Murphy for preference !) To-day we spend our lives trying to persuade manufacturers to let us have a few **sets** *for you*. What a change ! We must tell you that we can't hope to give everybody *exactly* what they want. **What we will promise you is, that we'll do our best to get you a set if you need one and if we can't do that, we'll keep your old one going strong for a bit longer.**

MURPHY DEALERS ARE PEOPLE YOU CAN TRUST

G. SALTER
ELLESMERE PORT
BROADWAY, WHITBY ROAD *Telephone : 292*

Right: Shortages were a fact of life in the Second World War and the 'wireless' was much in demand as the all-important channel for information and entertainment. Here, a radio dealer in Ellesmere Port reminds the public that sets are in short supply and they'll have to take what they can get.

Below: Best foot forward – Women's Land Army rally in Stockport in the Second World War.

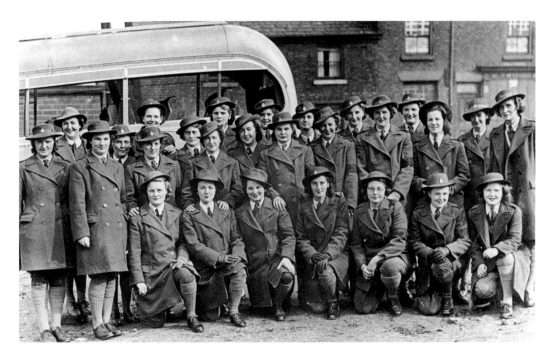

Index